Salt of the Red Earth

A CENTURY OF WIT AND WISDOM FROM OKLAHOMA'S ELDERS

by

M.J. Alexander

EDITOR: GINI MOORE CAMPBELL

Oklahoma Horizons Series

ISBN 1-885596-59-6
ISBN 978-1-885596-59-8
Library of Congress Catalog Number: 2007924919
Designed by Skip McKinstry
Printed by Jostens Publications

OKLAHOMA HERITAGE ASSOCIATION
1400 Classen Drive
Oklahoma City, OK 73106
888.501.2059
www.oklahomaheritage.com

EDITOR'S NOTE: The ages featured in *Salt of the Red Earth* reflect the individual's age the day they were photographed.

DEDICATION

*This collection is dedicated to Oklahoma's centenarians.
Their faces and stories linger, and have helped me imagine
the journey ahead of us all.*

*It also is dedicated to their caregivers—family by blood or by
choice—who tend to the elders, honoring who they are and what
they have done through unseen acts of quiet kindness.*

*And finally, it is dedicated to my family:
Ed, Alexander and Allegra Knight; Dale and Jennie Alexander;
and Jim, Gail and Kathryn Knight. Despite life spans nowhere
near 100 years, they are a constant source of wit and wisdom.*

Salt of the Red Earth
A CENTURY OF WIT AND WISDOM FROM OKLAHOMA'S ELDERS

The Centenarians

First you notice the hands.

The fingers are tapered, sometimes. Sometimes gnarled. Always expressive.

These are the hands—some calloused, some now as delicate as porcelain—that waved flags on Oklahoma's first day as a state, washed clothes in streams, wiped away tears, helped deliver babies now in their 80s. They held reins of mule teams, and clutched telegrams announcing the death of sons and husbands at war.

They are the hands of the very oldest people in one of our youngest states.

To commemorate Oklahoma's Centennial, I've spent a year visiting folks who were born in or before the statehood year of 1907. To find them, I crisscrossed the state's highways, main streets, and dirt roads, covering nearly 4,000 miles.

I met the centenarians where they lived, traveling through tornado sirens in Blackwell, forest fire haze north of Ardmore, and ice storms in Yukon. Temperatures ranged from 8 to 108.

They made it here by various means: the descendants of Native Americans forcibly marched on the Trail of Tears, the grandchildren of African-American freedmen, early settlers whose kin staked claims on the Land Runs, or who came to the territory as toddlers by covered wagon. Some were born in dugouts, sod houses, or squatters' cabins.

They welcomed me into their homes: well-appointed penthouses, ramshackle shotgun shacks, frenetic four-generation households, sparse rooms in nursing homes.

As I spent more time with the centenarians and absorbed their stories, I came to realize their unique significance.

They are America's last pioneers.

The elders within these pages show us 100 different ways to be 100. They are among an estimated 400 Oklahoma centenarians, and part of the fastest-growing demographic group in the United States. More than 70,000 centenarians live in the United States today; by 2060, their numbers are expected to surpass 1 million.

Although most of the centenarians I met were not accustomed to being photographed, they seemed remarkably at ease with the camera and with themselves.

After an initial protest—"I don't want to break your camera!"—they would settle in. Key aspects of their personalities—optimism, thoughtfulness, crankiness, curiosity—lived in the contours of their expressions. Radiant after talking of their life and insights, their faces shone with strength and an innate beauty. Their gazes were penetrating, unafraid.

Despite their varied circumstances, I found common traits: they are unassuming and direct, without conceit or self-consciousness. They wear no mask.

They are survivors, old souls in every sense.

Their gestures, features, and comments have been seasoned by a century living in a land of extremes, distilled to their essence beneath Oklahoma's cobalt skies, saffron suns, and cinnamon moons.

My original idea was to photograph them surrounded by artifacts of their lives: seated in cozy parlors lined with photographs, I imagined, or in rocking chairs on the porch. But sometimes their current living arrangements did not reflect the richness of their lives. Instead, I used a plain backdrop and ambient light, putting the focus squarely on their features and expressions. Ironically, stripping away the background resulted in a strong sense of place. To me, the faces convey the landscapes where they have lived for a century.

A copper wash over the images evokes the early photography of the American West— a legacy of hazy daguerreotypes, translucent photogravures, and albumen silver prints— that helped shape the world's imagination of the people and places of the frontier.

These are the people who helped shape the frontier itself and, in turn, were shaped by it. They embody strength and courage, grit and grace—qualities that are a tribute not only to the hundred years they have lived, but to the new century they helped make possible.

They are, truly, the salt of the red earth.

M J Alexander

ACKNOWLEDGMENTS

I was told it would be impossible—and it would have been, on my own.

The feat of finding and photographing 100 Oklahoma centenarians was made possible through the help of hundreds of people.

Thank you to the centenarians themselves for sharing their lives and trusting me to create their portraits. Thanks, too, to the thoughtful neighbors, relatives, reporters, friends, and caregivers who contacted me about their favorite elder.

I am also grateful to:

The **Centenarian Club of Oklahoma**, especially the **Rev. Richard Ziglar** for his indefatigable spirit in tracking down Tulsa-area elders and, in Oklahoma City, **Mary Lou Bates**, **Richard Amend** and **Pam Cullen** for their good humor and quick responses; **Julia Kirt** of the Oklahoma Visual Arts Coalition and **Betty Price** and **Scott Cowan** of the Oklahoma Arts Council for their encouragement; **Lisa** and **Bentley Edmonds** for their early and unflagging belief in and support for the project, including lending their car when mine was unusable; **Maggie Brown** and the Tulsa Historical Society for the portraits' first presentation; **Steve Drew** of Impressions Printing for his quick work and good humor; **Jay Gourley** of Photo Factory for his attention to detail;

Debbie Musick, **Carolyn Messick**, **Ayumi Corn** and **Clarissa Sharp** for their role as sounding boards; and **Elizabeth Meares** of Southwestern Publishing for brainstorming sessions.

Dianne Lynch for always being near, though a timezone away. **Shauna Struby** for coming through on a moment's notice. **Hedgebrook Writers' Colony** for the gift of time and space. **Joyce Tenneson** for her insight and generosity and **M.V. Swanson** for her wise counsel.

The Oklahoma media for helping put out the call for centenarians, especially **Louisa McCune-Elmore** of *Oklahoma Today*, **Brian Sargent**, **Alan Herzberger** and **Chris Landsberger** of *The Oklahoman*, **Ruth Ann Replogle** of *The Enid News*, **Lori Oden** of *Art Focus Oklahoma*, and **Scott Gurian** of KGOU.

Jeanie McCain Edney, for relentlessly championing the portrait project, and the **Oklahoma Centennial Commission** and **Tulsa Centennial Commission** for providing seed money for the Statehood Day 2006 exhibition in Tulsa. **Lori** and **Bond Payne** for their enthusiasm and the can-do attitude of **Shannon Nance** and **Gini Moore Campbell** of the Oklahoma Heritage Association.

Salt of the Red Earth

My soul, the time!
It went so fast.
Why, it seems I was just
six years old.

ZELDA MEYER RHOADES

Chapter I LIVING IN THREE CENTURIES

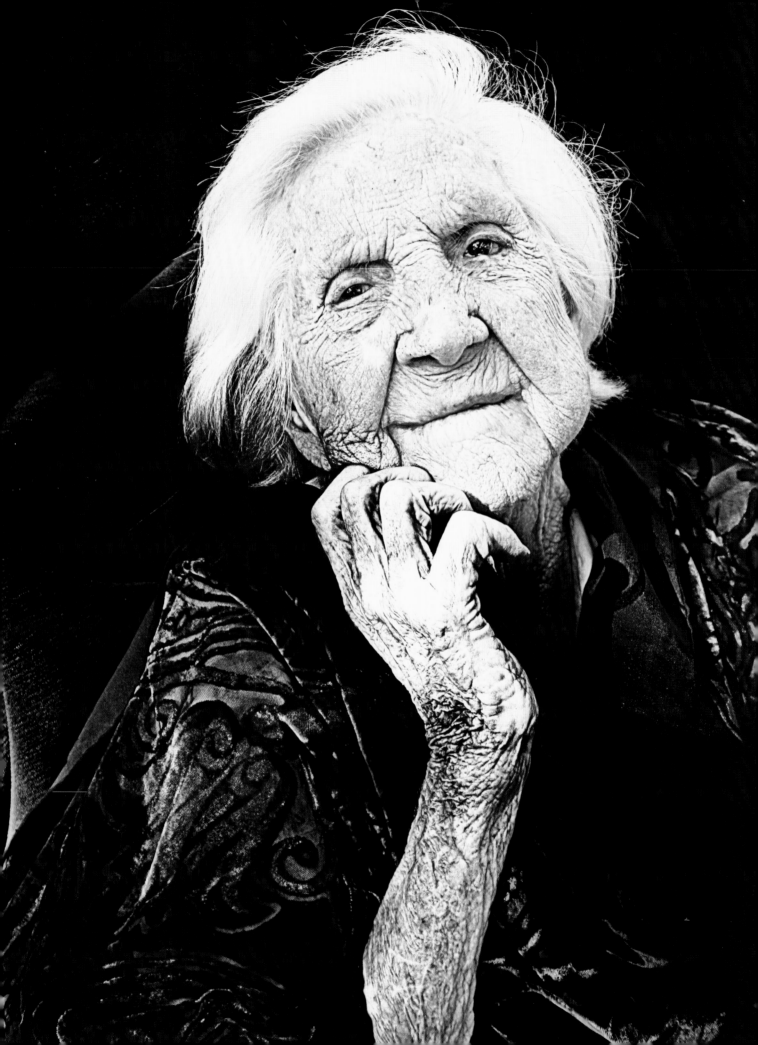

Be honest. Go to church. Pay your bills.

Blanche Davidson Loman, age 107
Grant, Oklahoma

Born November 2, 1898 in Copenhagen, Arkansas.
Photographed August 9, 2006 in Grant.
Youngest of nine children.
Lives independently.
Son throws birthday barbeque for 150 of her friends every even year.

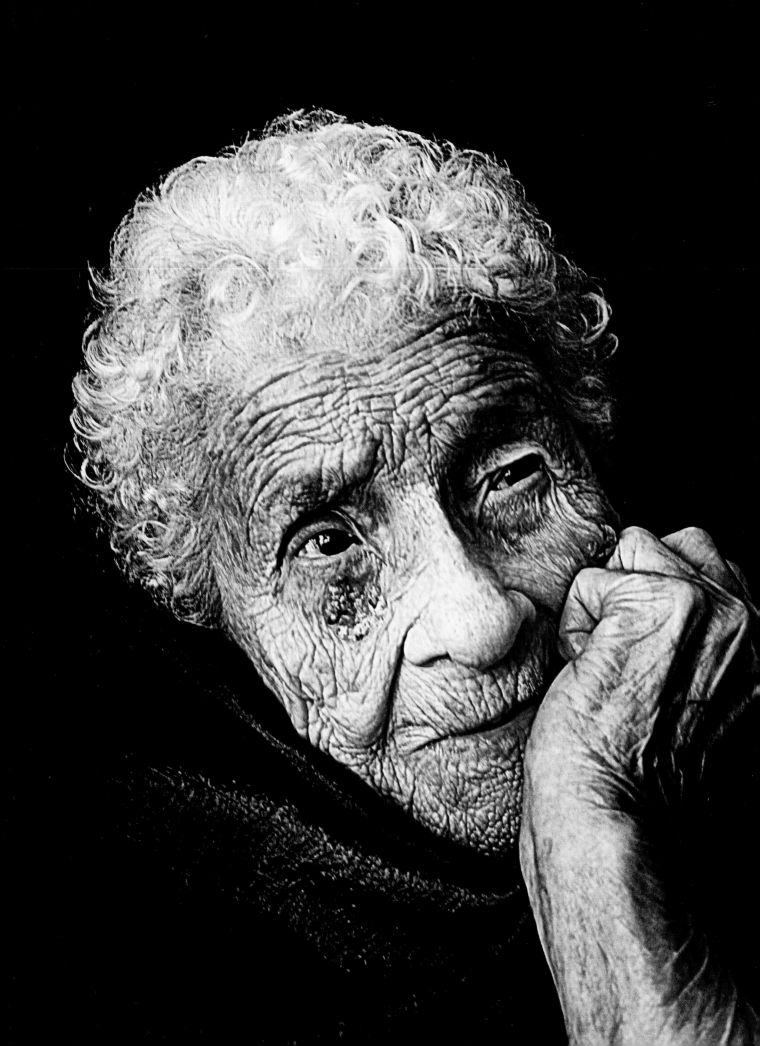

I have no regrets.

Haddie Will Myrtle Hottle Austin Payne, age 107
Stratford, Oklahoma

Born September 27, 1898 in Stratford, Chickasaw Nation, I.T.
Photographed August 19, 2006 in Grant.
World War I widow.
Oldest of 18 children.

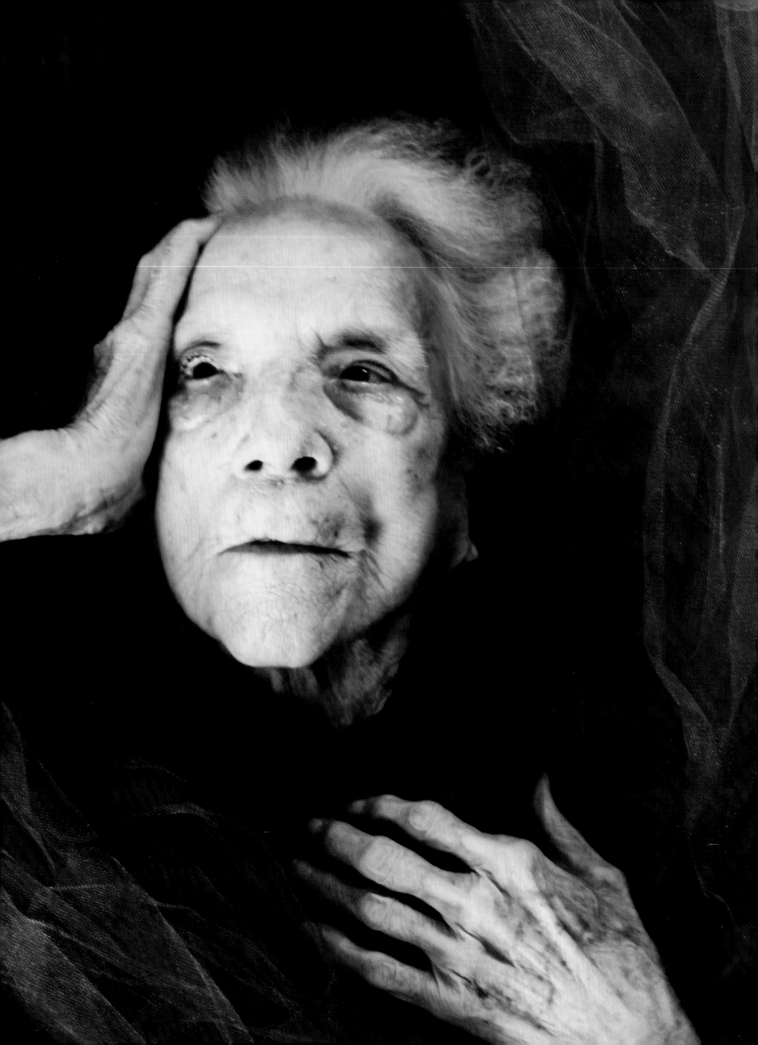

I've saved things all my life. It's hard for me to realize that I don't need any of this stuff.

It's real friends that truly matter.

Kristine Klostermyer Brown, age 108
Alva, Oklahoma

Born September 8, 1897 in Bates County, Missouri.
Photographed August 11, 2006 in Alva.
Oklahoma's oldest resident.
Began teaching in one-room schoolhouse.
Retired as professor of mathematics.

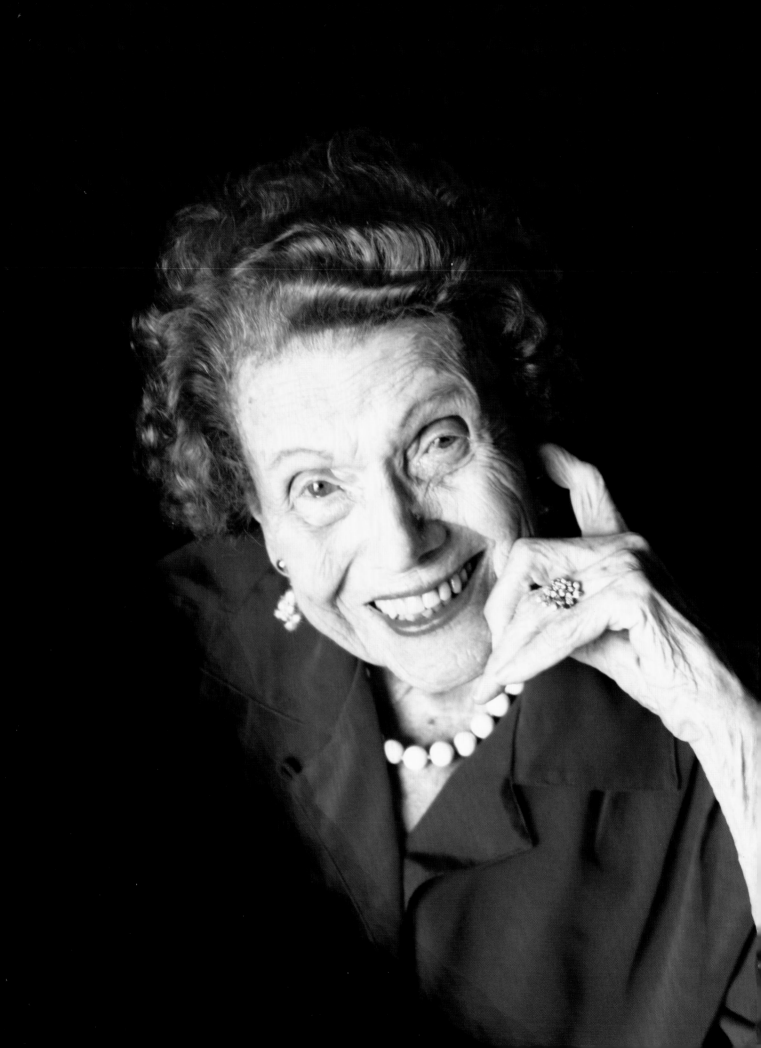

My soul, the time! It went so fast.
Why, it seems I was just six years old.

Zelda Meyer Rhoades, age 107
Duncan, Oklahoma

Born December 10, 1899 in Alma, Kansas.
Photographed August 19, 2006 in Duncan.
House mother for 14 years at Kappa Alpha Theta sorority houses in Topeka and
 Washburn, Kansas.
Moved to Oklahoma in her 90s to be closer to her daughter.

The Dust Bowl didn't look like dust. It looked like a storm a comin,' red and rolling.

OWEN ESTEL "JACK" KNIGHT

Chapter II **HISTORY**

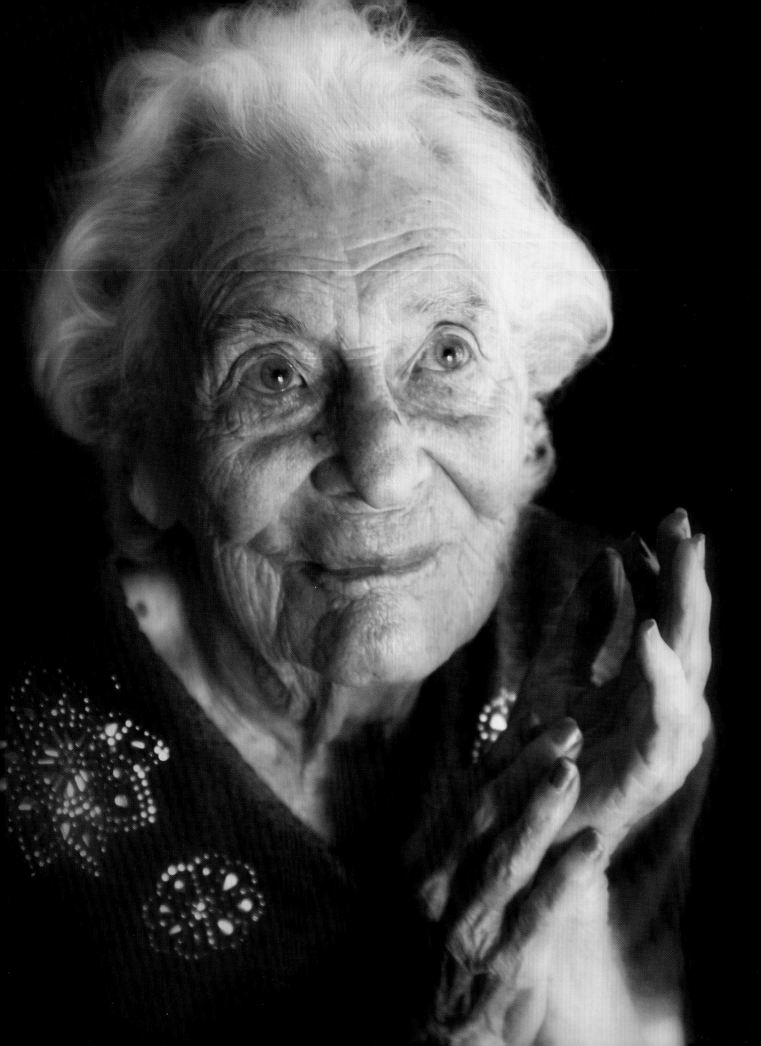

Grandfather Graham, my mother's father, was on the Union side. Grandfather Mayfield, my father's father, fought for the Confederate side. I helped take care of them when I was a girl. They'd argue a lot of the time. Had bedrooms on the opposite sides of the house.

Allie Viola Mayfield Strecker, age 99
Oklahoma City, Oklahoma

Born March 15, 1907 in Indiahoma, O.T.
Photographed August 18, 2006 in Oklahoma City.
Sixth of seven children.
Parents participated in 1889 Land Run.
But they didn't get anything—you'd have to be pretty fast to get anything.
Rode out Dust Bowl near Chester, Oklahoma.
Sometimes the dust storms would be so dark it'd be like night. If we were caught out, we'd have to feel our way down the fence. We were at a neighbor's house once, and had five or six miles to get home, feeling the fence all the way. You just can't imagine people could live through that.

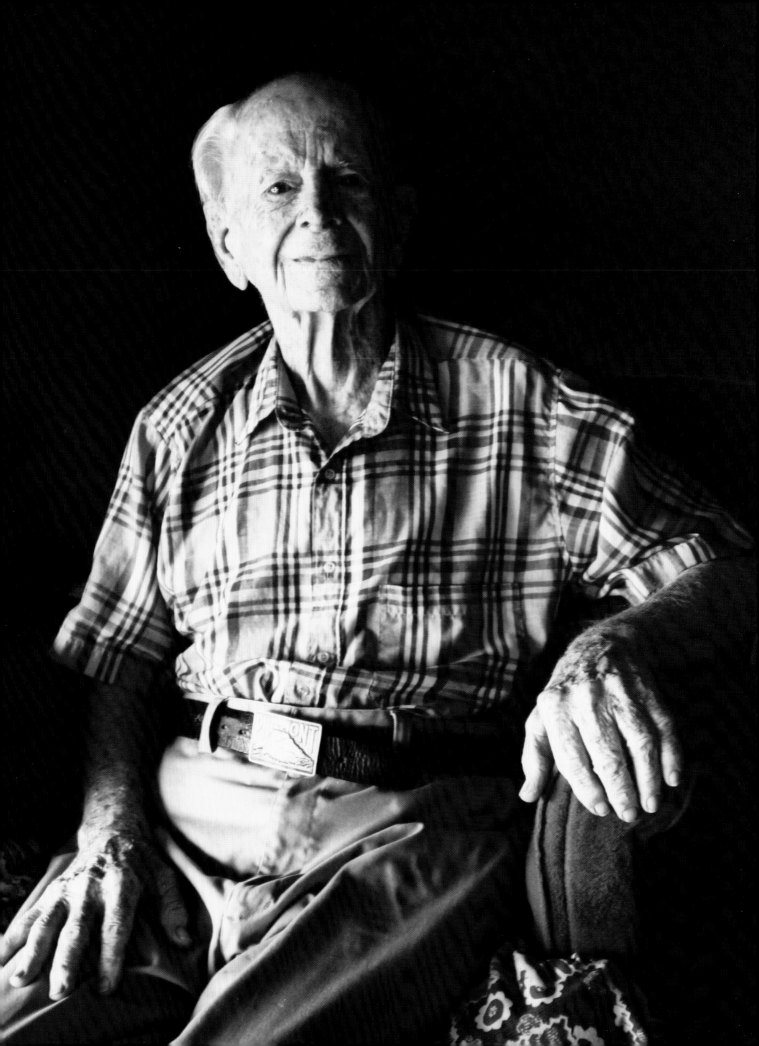

When I was five years old, I saw five men hanged simultaneously.
Can you imagine? All these men were stationed over a trap door.
The pastor came in and gave a little short talk. The sheriff came
and asked if they had anything to say. None did. They walked
them to this platform, and then it dropped. You could hear them
flanking around in there. Their bodies had dropped, and you
couldn't see them, but you could hear them. Horse thieves.
They were all horse thieves. It was so terrible.
That moment stays with me.

Raymond Lee Fish, age 102
Oklahoma City, Oklahoma

Born February 11, 1904 in dugout in Kingfisher, O.T.
Photographed August 18, 2006 in Oklahoma City.
World traveler.
Member, Oklahoma Aviation and Space Hall of Fame.
Oklahoma's oldest aviator, retired flight instructor.
Mother made 1889 Land Run as an eight-year-old.
His 1936 Dodge radio repair truck is on permanent display at the Oklahoma History Center.

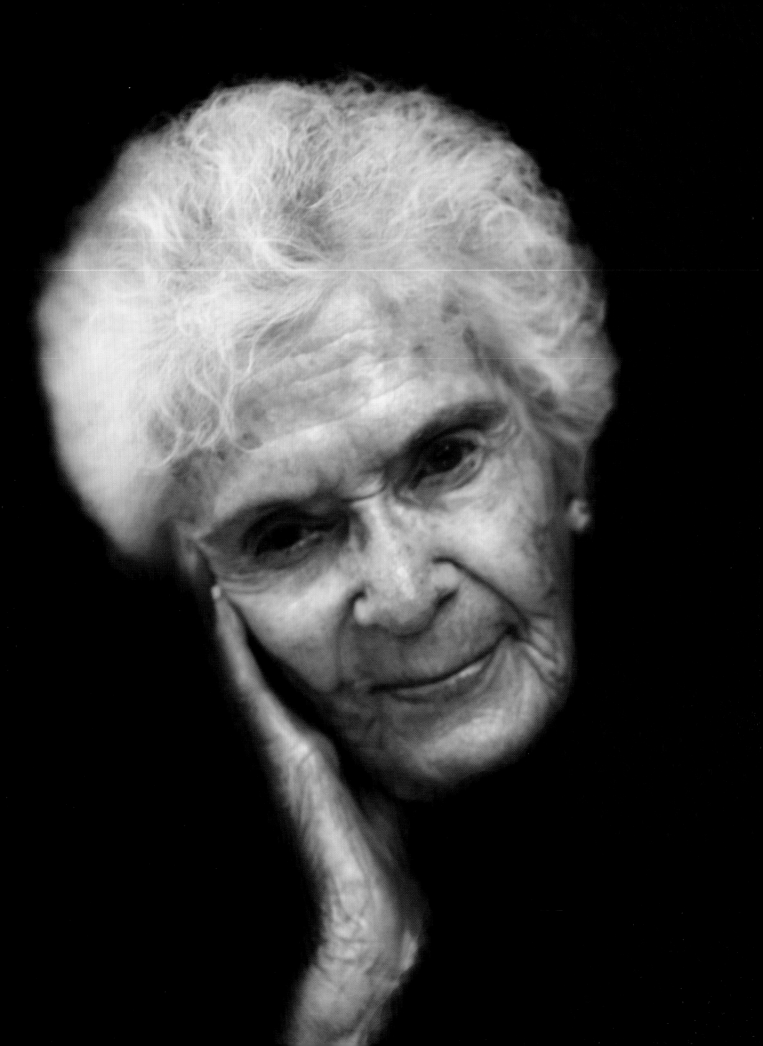

We went West for mother's health when I was four, in 1911.
We traveled in a covered wagon, and we kids would gather
cow chips to burn when we stopped.

In New Mexico, Dad was a carpenter who built coffins in World
War I, to put servicemen in. They'd dig a trench and line them up,
and the next day they put in another layer of coffins. I remember
it very clearly. They were dying by the thousands.

Ruby Lee Crabb Perkins, age 99
Oklahoma City, Oklahoma

Born April 8, 1907, near Saddle Mountain, Comanche County, O.T.
Photographed May 20, 2006 in Oklahoma City.

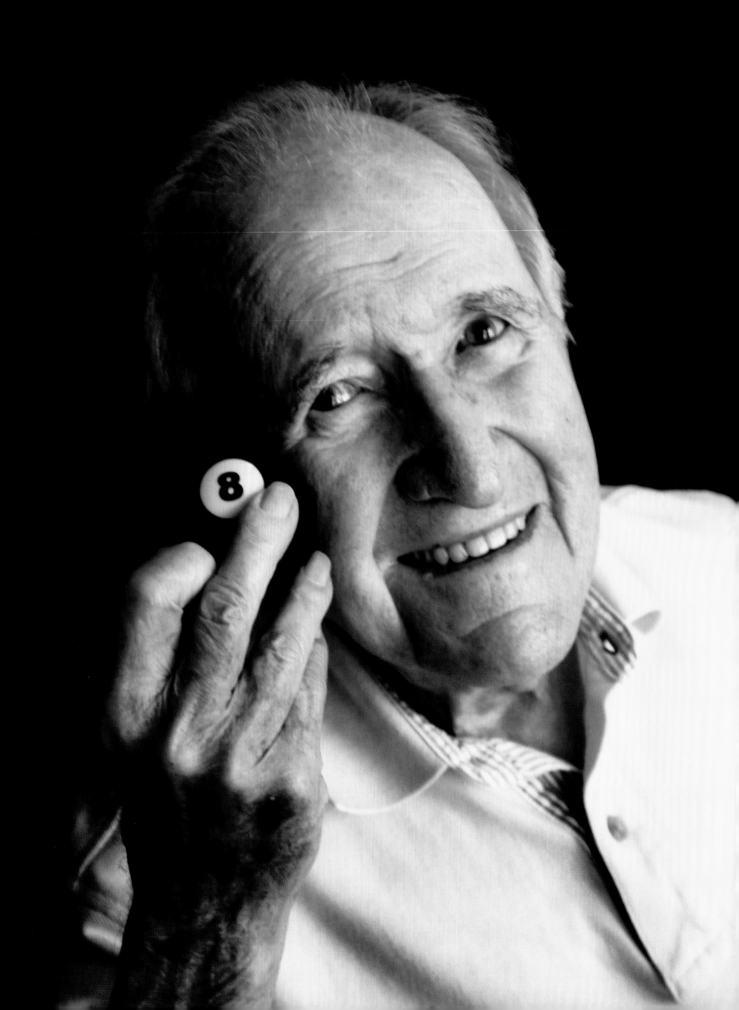

All my family had the influenza of 1918, except me. I had to tend the cows for us and the neighhors, I was the only one not sick.

Didn't serve in World War I. Too young. Didn't serve in World War II. Too old. I guess that's the reason I'm still here.

Millard Wesley Gaddie, age 104
Bethany, Oklahoma

Born June 8, 1902 in Campbellsville, Kentucky.
Photographed August 7, 2006 in Bethany.
Takes no vitamins or medications.

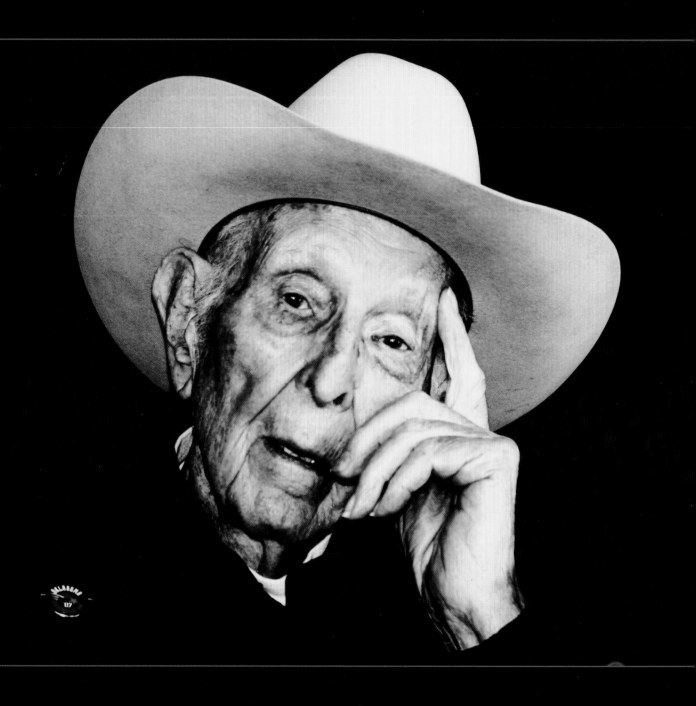

I was born on the Indian reservation and I knowed how the white men ripped those Indians off. Pitiful, it was just pitiful to see. I seen it with my own eyes. Just you wait. Let them keep those casinos for awhile. They'll get it all back…

Some folks were afraid of the Modocs, afraid they'd go on the warpath.

Did it ever happen?

Well, it almost did, once. An Indian kid goes to Seneca and gets a sack of candy. They told him he had to pay, but the boy didn't understand – now this is a story that came through a Modoc. Well, he was out there by the hitching post eating the candy and the shopkeeper said he always wanted to kill a Modoc. So he shot him.

Well, the Modocs ended up camped out on the hill overlooking the town. And history tells us that means they were going to burn the town. But there weren't that many. They were expecting the other tribes to come. No one came.

A historian came out to talk to me. She heared I knowed about the Modocs. She went to good schools, but only knowed book history. Her history showed they killed a man there over a pair of boots. But that's not how the story goes. It was a boy, over candy.

Arnold B. Richardson, age 100
Miami, Oklahoma

Born June 29, 1906 in one-room squatter's cabin, Eastern Shawnee Nation, I.T.
Photographed February 27, 2007 in Miami.
Inducted as honorary member of Modoc Tribe of Oklahoma.
Father cleared brush, pulled chain for Quapaw Indian Agency surveyor for $15 a month.
Longtime grave digger, Modoc Tribal Cemetery, Ottawa County.
Philosophy:
We all could have a good, reasonable, comfortable living if the world was sensible. But it's not. It's a dog-eat-dog world, and I got good teeth.
On why he did not remarry after his wife died:
Well, the ones I wanted, I couldn't get. And the ones I could get, the devil wouldn't have.

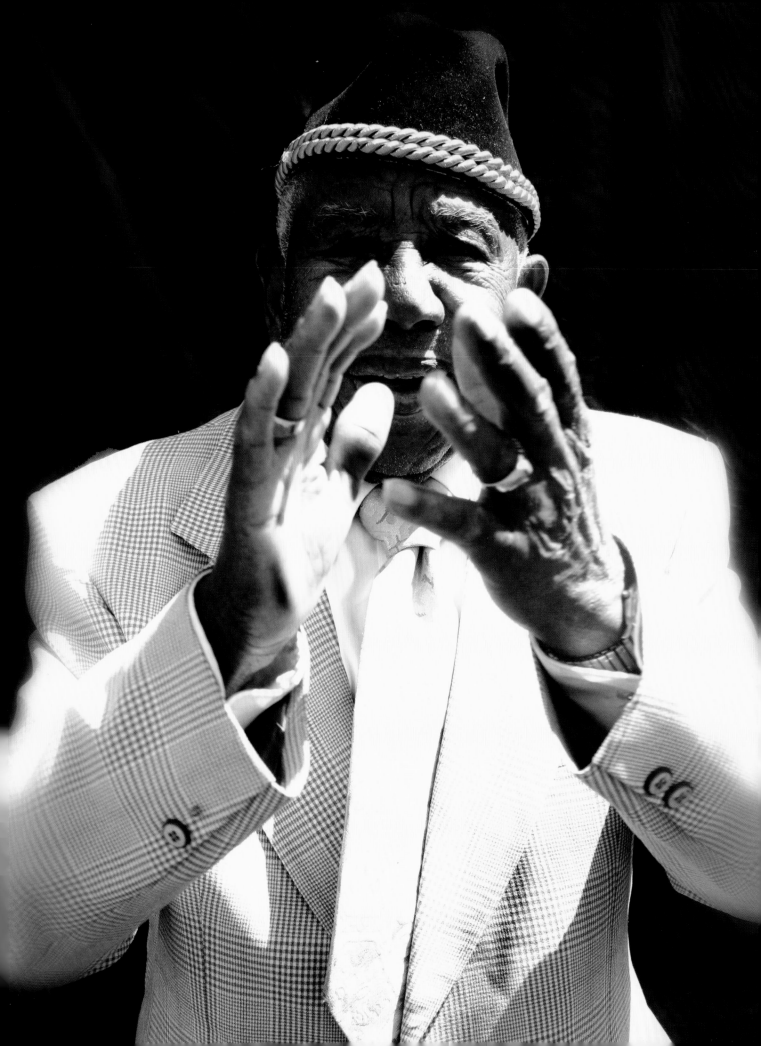

I saw blood that day...I used to be an angry young man, full of hate for what happened to me. That anger stayed with me for many years, but I have forgiven those people.

Rev. Otis Granville Clark, age 103
Tulsa, Oklahoma

Born February 13, 1903 in Meridian, O.T.
Photographed May 18, 2006 in Oklahoma City.
Evangelist.
Oldest survivor of 1921 Tulsa Race Riot.
His house was burned, his dog killed, his friend shot, and his stepfather killed in the violence.
Butler to Joan Crawford in Hollywood's golden era; served Charlie Chaplin and Clark Gable.
Continues missionary work; made three-week visit to Zimbabwe at age 103.

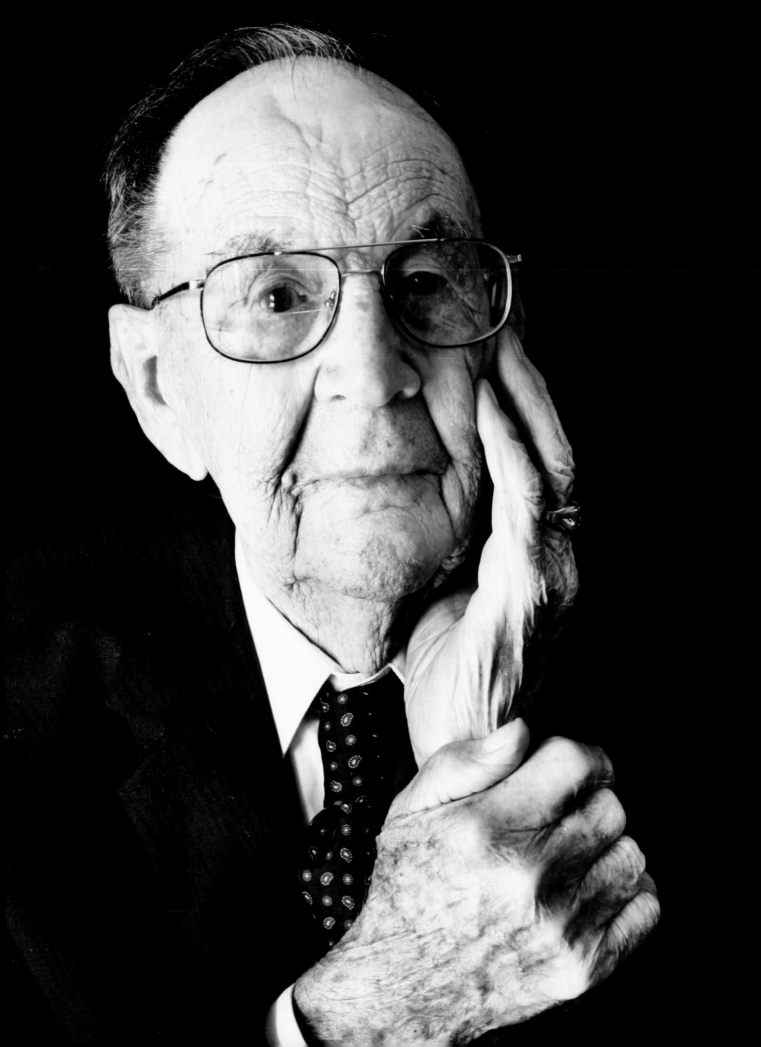

I remember the Dust Bowl days. Tough living. In the '30s, the dirt blew so hard you'd have to take a shovel to get it off the floors. It was just a dark cloud coming over, gray in the afternoon. There was no damage to the house, but all our other buildings were ruined. My mother had all the canned goods in the basement, and the wind took everything out of the basement. Took everything out of the wheat field. We started all over.

Melvin Lewis Eckert, age 99
Enid, Oklahoma

Born September 4, 1906 in Venedy, Illinois.
Photographed August 11, 2006 in Enid.
Has won as many as 22 Garfield County Fair ribbons a year for his flowers, vegetables, latchwork, and rugs.

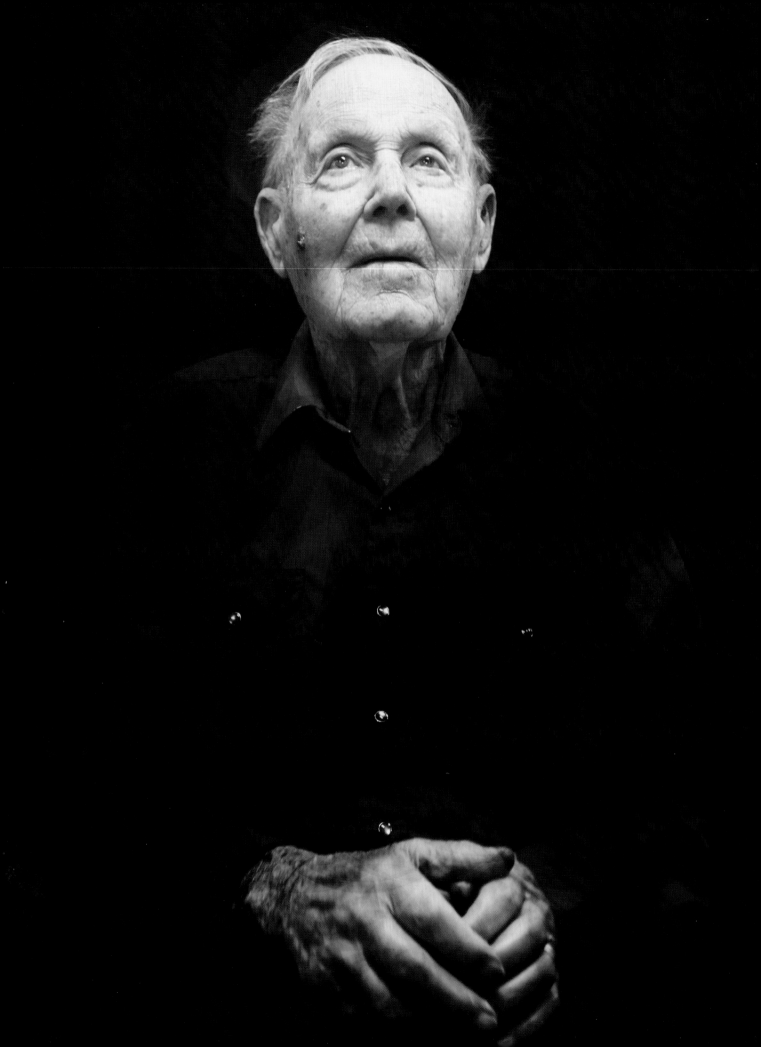

I moved away from Elk City for about eight months, but I came back. Went to California for work, but there was no work there either. So I came back. If you're going to be unemployed, you might as well be unemployed at home.

In 1934, I believe it was, the Dust Bowl didn't look like dust. It looked like a storm a comin', red and rolling. When we came out of the storm cellar, it had rolled on over and we couldn't hardly see anything.

My wife would cook supper and she'd spread the oil cloth over the table and put down the dishes. By the time we sat down, the plates were covered up with dust. You could write your name on them.

Owen Estel "Jack" Knight, age 101
Elk City, Oklahoma

Born April 23, 1905 in Elk City, O.T.
Photographed September 14, 2006 in Elk City.
Retired farmer.

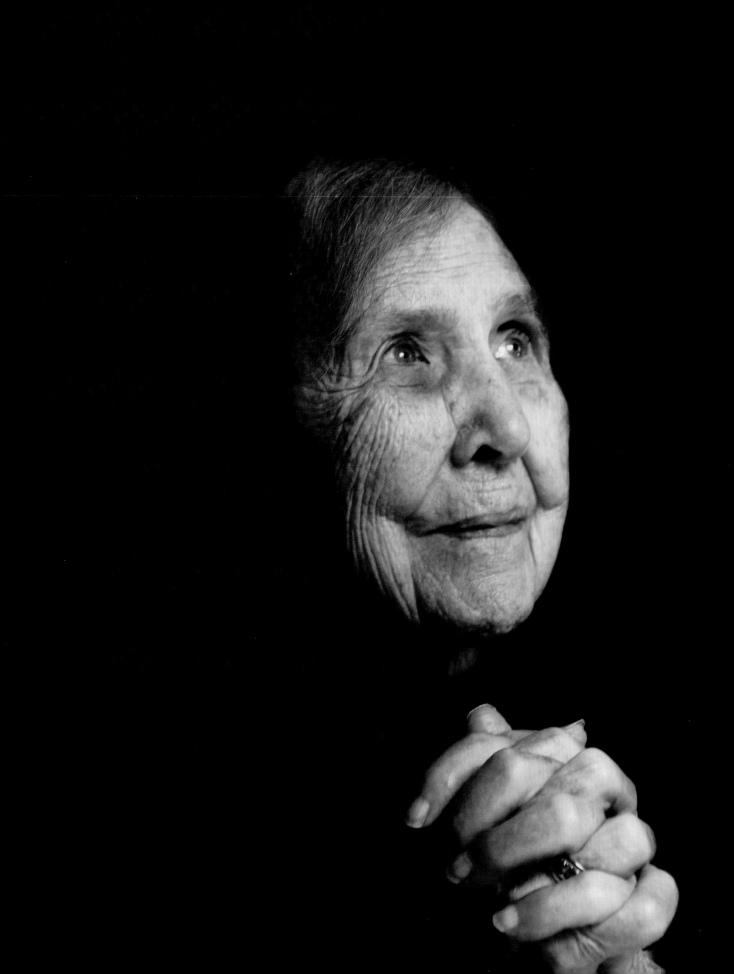

I was on my way to church on Sunday morning, December 7, when I heard the air raid sirens.

I was going to turn around and go home. But then I told myself if ever there was a time to pray, this was it.

Nena Ruth Gibbins Smith, age 98
Oklahoma City, Oklahoma

Born December 25, 1907 in Lawton, Oklahoma.
Photographed June 28, 2006 in Oklahoma City.
Moved to Pearl Harbor, Hawaii, as nanny to military family in 1941.
Became civilian military employee, transported Army vehicles to port for shipping.
After war ended, taught sixth grade.

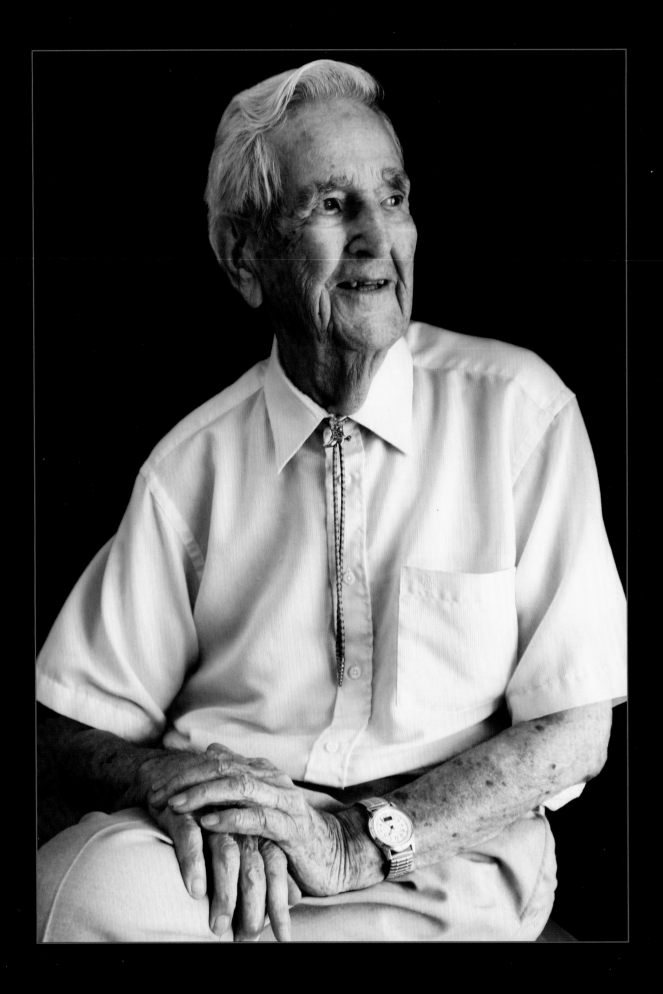

I would wish for a world without war.

I remember loading up with wounded Marines in Iwo Jima. We had to step over the dead. We'd only bury them at night. They'd put them on a board with a piece of metal and wrap them up and say a prayer and let them go. I had two sons myself, and worried that these Marines' parents would never know where they were.

Dawson Gorman, age 99
Oklahoma City, Oklahoma

Born May 6, 1907, near Kiowa, Choctaw Nation, I.T.
Photographed August 7, 2006 in Oklahoma City.
Named for John Dawson, ancestor who survived the Trail of Tears.
Witnessed Iwo Jima flag raising from onboard the USS *Hendry APA-118*.

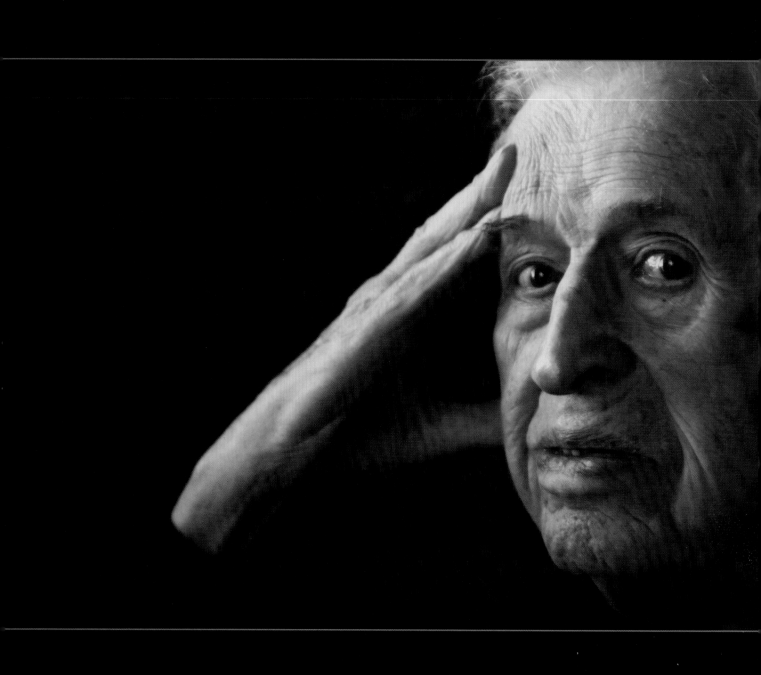

I, Brad Henry, Governor of the State of Oklahoma, do hereby proclaim January 18, 2007, as Dr. Paul Lingenfelter Day in the State of Oklahoma in honor of his 100th birthday and lifetime of dedicated medical service.

State of Oklahoma Proclamation
December 18, 2006

Dr. Paul Brann Lingenfelter, age 100
Yukon, Oklahoma

Born January 18, 1907 in Clinton, O.T.
Photographed February 4, 2007 in Yukon.
Thoracic surgeon trained at the University of Oklahoma and UCLA.
Attended 1936 Olympic Games in Berlin, Germany.
Took China Clipper's first transpacific flight as Pan Am's resident physician in the Pacific.
Volunteered to serve with the 21st Evacuation Hospital during World War II in New Guinea, Guadalcanal, and Bougainville.
Trained at Princeton University in Japanese language and reconnaissance work prior to planned Allied invasion.
Promoted to lieutenant colonel.
Returned to Clinton, Oklahoma where he worked until retiring in 1977.

*I've always told people
I was older than
Oklahoma.*

SARAH EDNA RAY COOPER

Chapter III 1907: STATEHOOD

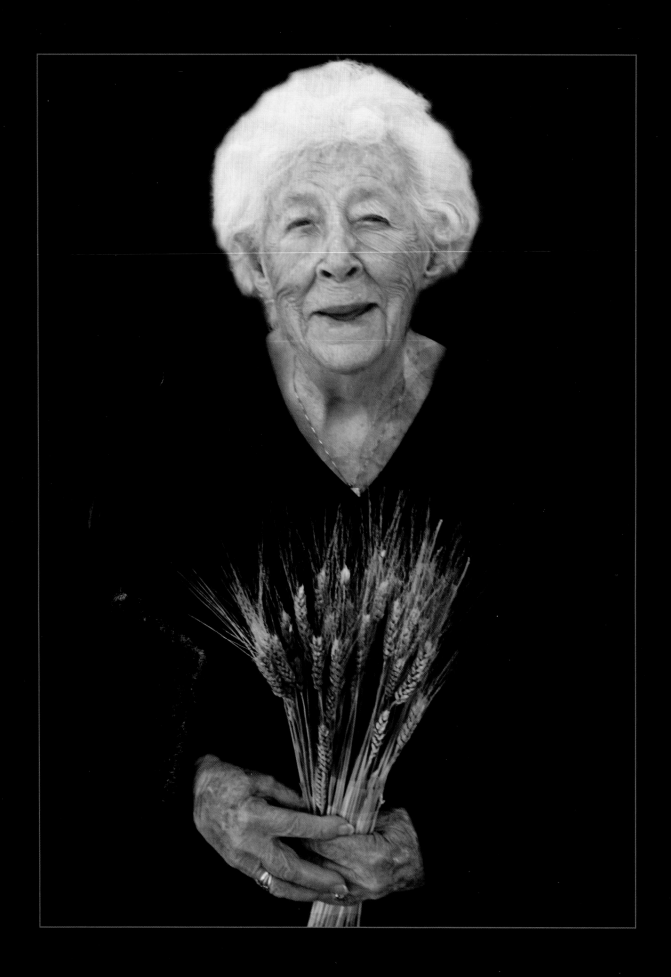

All I can remember is that my mother told me I was the first white baby born in the State of Oklahoma, born right before lunch on the day Oklahoma became a state, between 10:30 and 11 o'clock.

Mildred Alice Justice Hurt, age 99
Geary, Oklahoma

Born Statehood Day, November 16, 1907 in Geary.
Photographed February 4, 2007 in Yukon.
Seventh of 10 children.
Father was Justice of Peace E.A. Justice.
Father's parents met minister on trail, and were married on horseback.
Always wears gold pendant in shape of Oklahoma, with diamond representing Geary;
 gift from family on her 75th birthday.

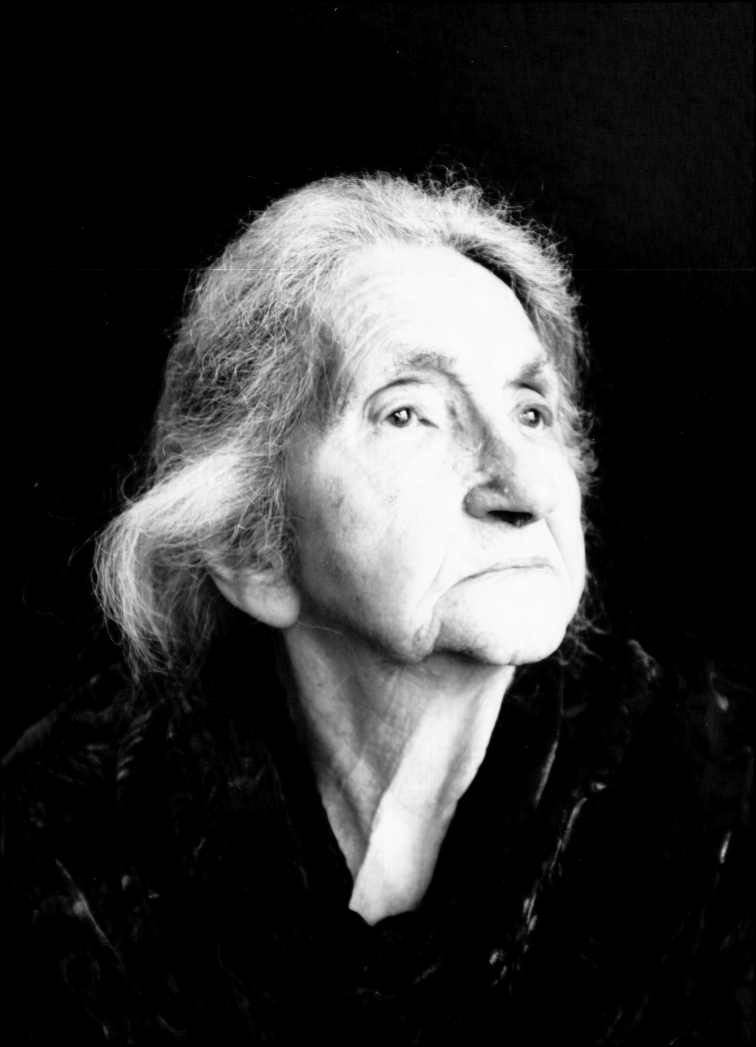

I can remember when they'd bring our mail and it said 'Bowers, I.T.' I was 7 when Oklahoma became a state.

I have no idea why I lived so long. I just kept living. Didn't think I'd ever make it.

Myrtie Pearce Cooley, age 106
McAlester, Oklahoma

Born May 10, 1900 near Bowers, Choctaw Nation, I.T.
Photographed August 9, 2006 in McAlester.
Moved into her first house with indoor plumbing in 1961, at age 61.

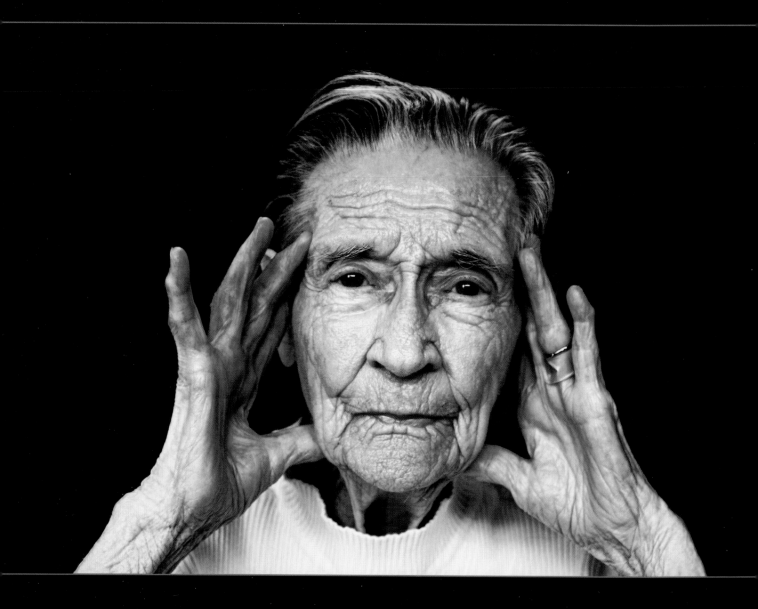

I've always told people I was older than Oklahoma.

Sarah Edna Ray Cooper, age 99
Broken Arrow, Oklahoma

Born January 24, 1907 in Marietta, Chickasaw Nation, I.T.
Photographed June 16, 2006 in Tulsa.
Retired saleswoman.

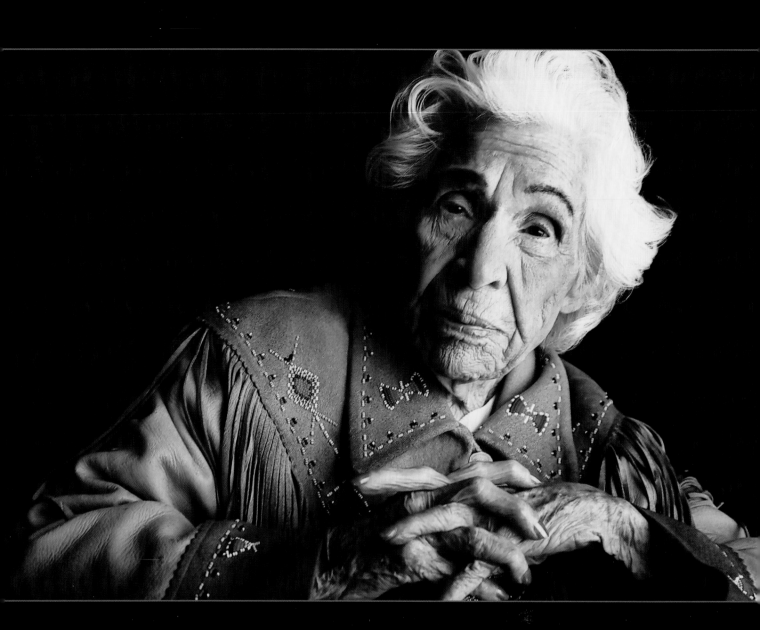

I'm six years older than Oklahoma. I remember I could put I.T. down, but I had a hard time learning to spell Oklahoma. I was in first grade at the time at Catholic boarding school, Indian boarding school. My older sister and I were sent there. Mother died in childbirth with a blue baby when I was 2 or 3.

Mary Lee "Marie" Edwards Boudreau, age 105
Oklahoma City, Oklahoma

Born November 5, 1901 in Antlers, Choctaw Nation, I.T.
Photographed January 26, 2007 in Oklahoma City.
Original Choctaw allotee.

Just keep on living, child.

RUBY LEE KORNEGY DOBBS

Chapter IV HOW TO BE ONE HUNDRED

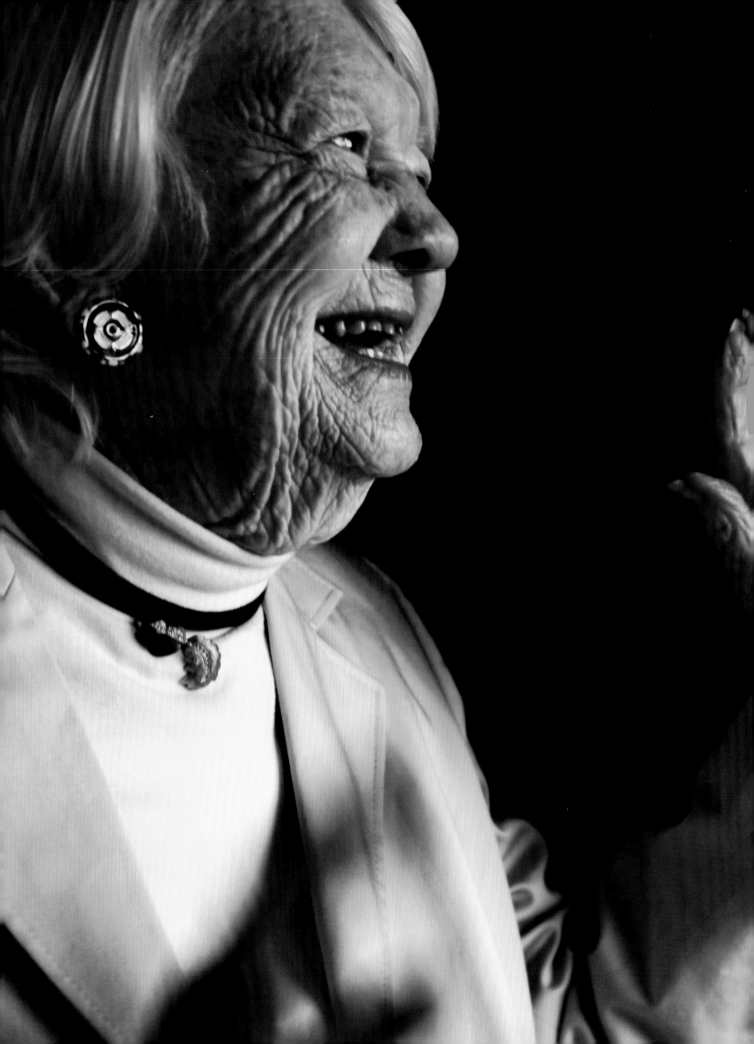

I've never had a bad day in my life. My life today, I can't live it again so I have only myself to blame if it's wasted. I have to live one day at a time.

Ida Mae Woody Wilson, age 99
Oklahoma City, Oklahoma

Born December 24, 1907 in Ardmore, Oklahoma.
Photographed February 17, 2007 in Oklahoma City.
Retired Southwestern Bell supervisor.
Attended 80 consecutive seasons of University of Oklahoma football—walks 72 rows up to
 seats in Row 64.
Celebrated 99th birthday in Las Vegas dining in Eiffel Tower Restaurant at Paris Casino.
Ancestors came on Trail of Tears.
Parents born in Cherokee Nation, I.T.

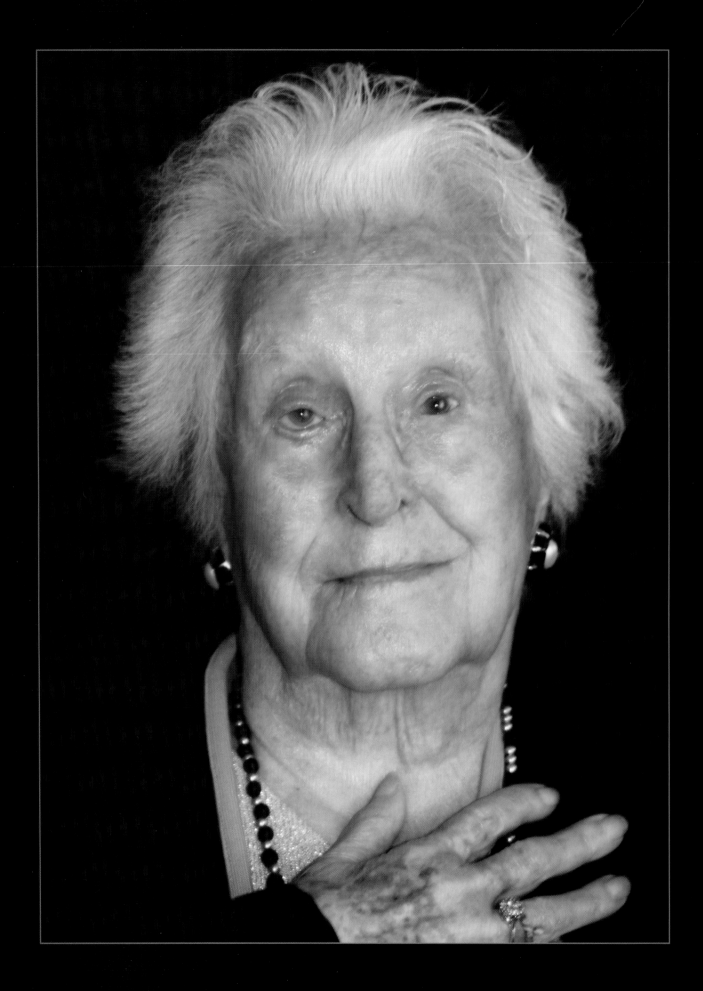

Living to be 100 is hard work. Try it and find out.

Elsie Chase Kilpatrick, age 99
Tulsa, Oklahoma

Born May 29, 1906 in sod house near Freedom, O.T.
Photographed May 23, 2006 in Tulsa.
Earned degree in home economics from Oklahoma A&M, with letters in riflery and softball.
Taught elementary school for 25 years.
In 1937, while living in Bloomfield, New Jersey, watched the Hindenburg fly over her house
 on its way to the doomed landing in Lakehurst.
Rode to church in Model-T on golden anniversary to renew vows with Lester Kilpatrick.
Celebrated 90th birthday snorkeling with granddaughter in British Virgin Islands.

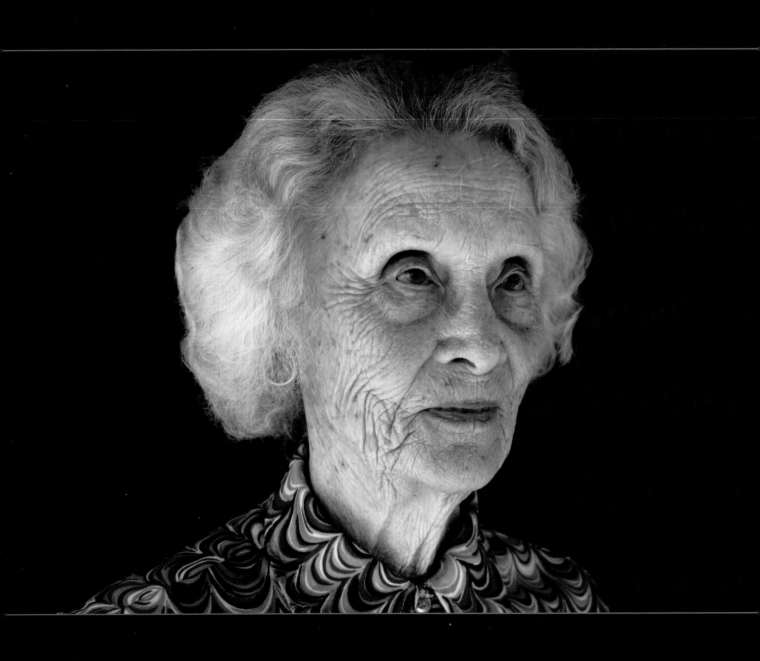

I had bone troubles. When I was 5, they didn't think I'd live to be 10. When I was 10, they said I wouldn't live to be 15. Boy, they'd be surprised now.

Ora Reed Holland, age 105
Tulsa, Oklahoma

Born December 24, 1900 in Rosebud, Missouri.
Photographed May 12, 2006 in Tulsa.
Lives independently.
Drives to church on Sunday.
Mows her own lawn.

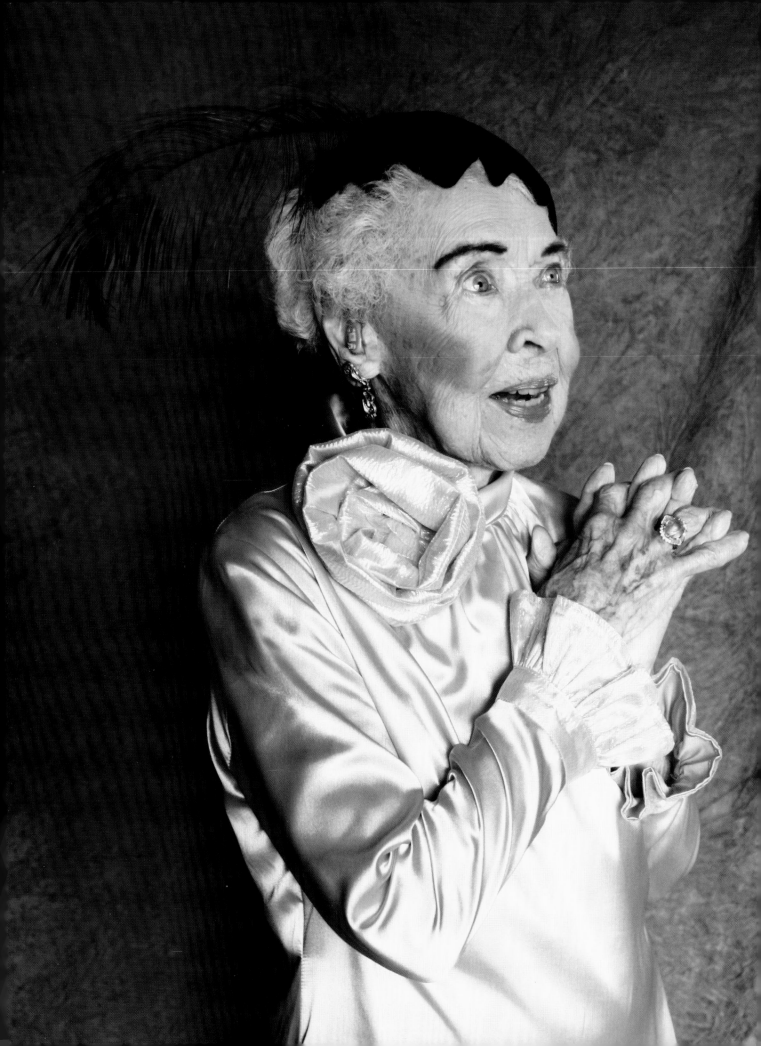

I've kept busy all my life, mentally as well as physically. I try to keep my mind active all the time. I still take dancing lessons every Friday. The movement of dancing is delightful. When you are moving to the beat of the music, you're in harmony. It's a wonderful feeling.

Doris Eaton Travis, age 102
Norman, Oklahoma

Born March 14, 1904 in Norfolk, Virginia.
Photographed August 19, 2006 in Norman.
Oldest living Ziegfeld Follies chorus girl.
Graduated cum laude from University of Oklahoma with history degree at age 88.
Owner and operator of Travis Ranch.

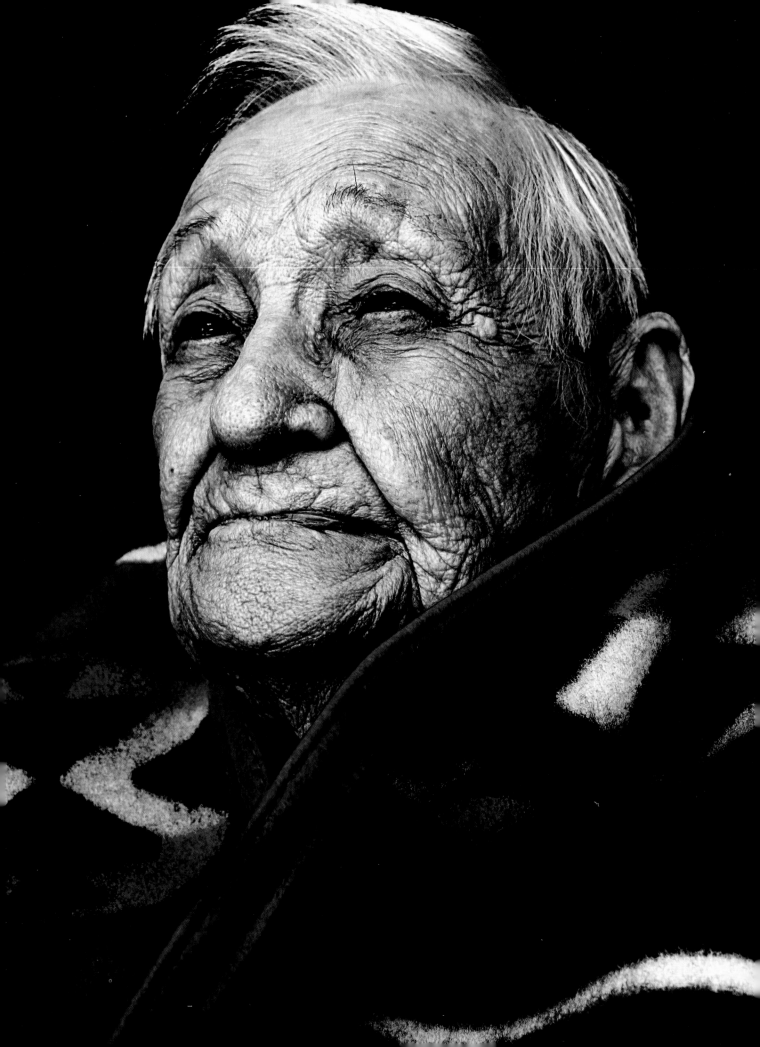

I try to do the best that I can. I try to be kind.

Lucy Etta Benham Nelson, age 101
Carson, Oklahoma

Born February 6, 1905 in Carson, Creek Nation, I.T.
Photographed June 16, 2006 at tribal celebration in Okmulgee.
Original Muscogee/Creek allottee.

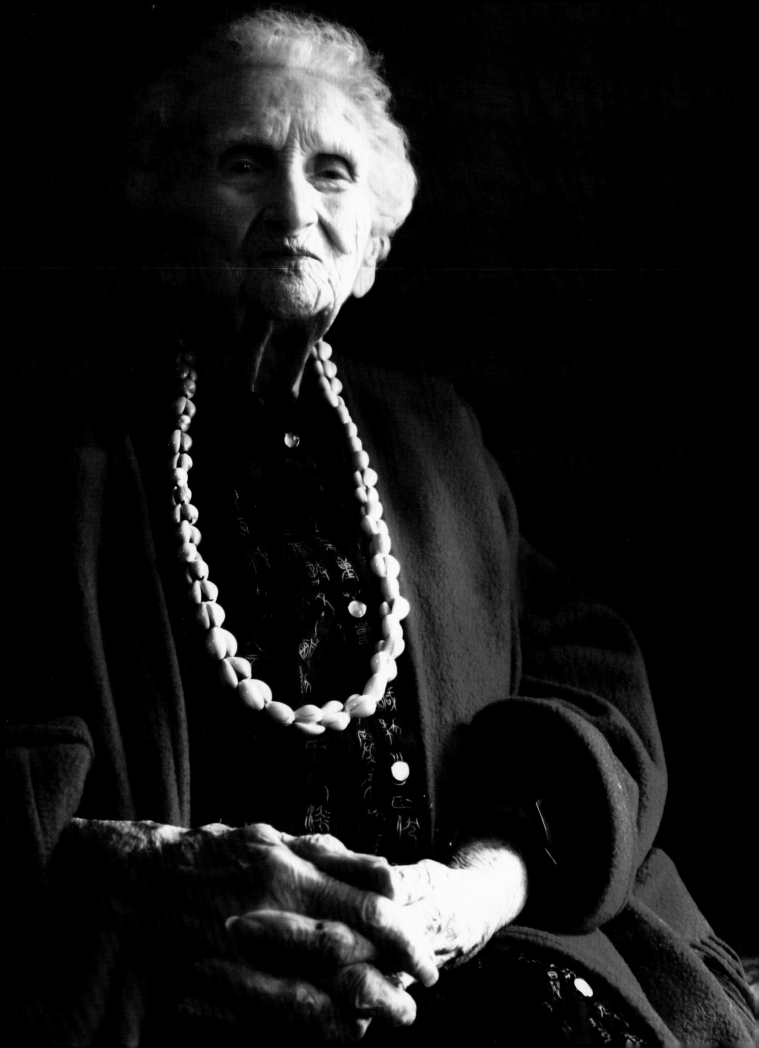

I never did think about how long I was going to live.
I just thought about HOW to live.

Sarah Harmon Armstrong, age 103
Okmulgee, Oklahoma

Born March 10, 1903 in Putman, O.T.
Photographed May 23, 2006 in Okmulgee.
Mother died from childbirth complications; raised by grandparents.
Registered Nurse in Norman Public Schools from 1935 to 1970.
Has twin great-great grandchildren.

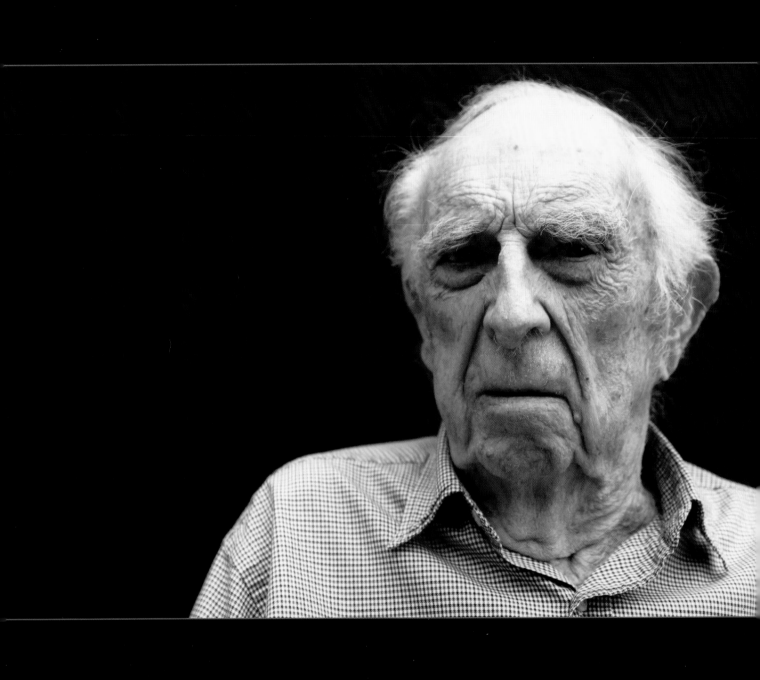

I just keep breathing.

William Herbert "Bill" Kennedy, age 100
Tulsa, Oklahoma

Born May 11, 1905 in Enid, O.T.
Photographed May 1, 2006 in Tulsa.
Avid golfer; has played courses from coast to coast.

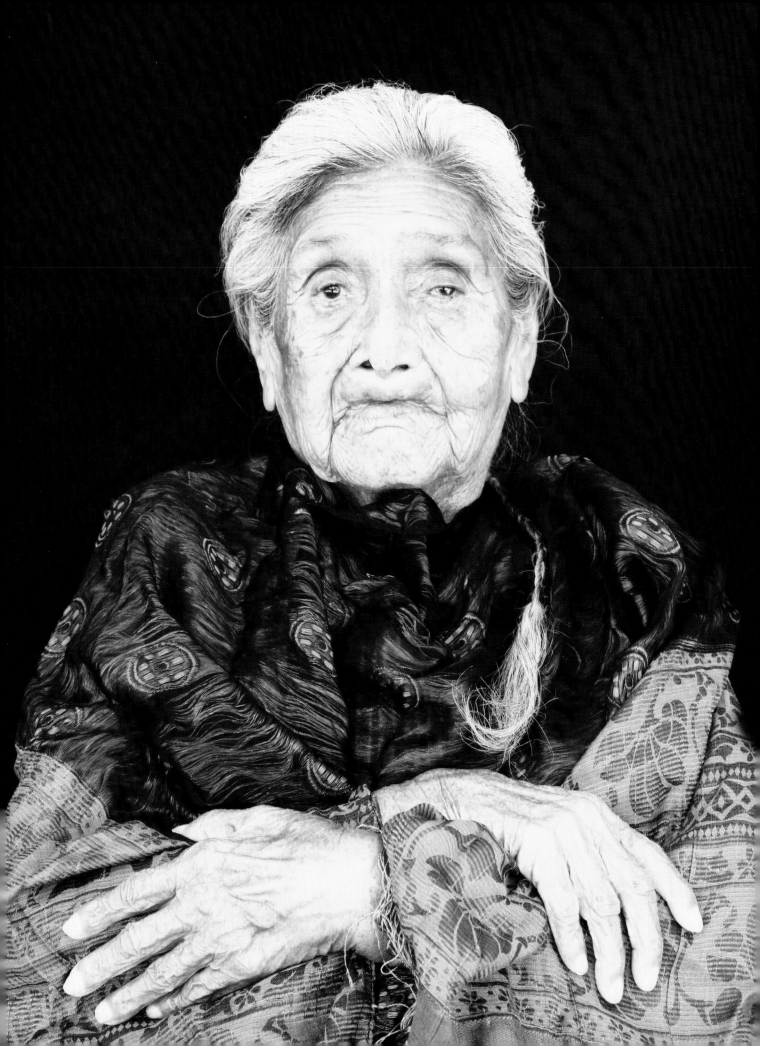

I'm glad that God let me live so long, all these years.
And I'm glad I am Choctaw. Indians are strong.
They can endure.

Mattie Simpty Northrip, age 100
Moyers, Oklahoma

Born May 18, 1906 near Moyers, Choctaw Nation, I.T.
Photographed August 9, 2006 in Moyers.
Full-blood Choctaw.
Fluent in native Choctaw language.
Orphaned by age 11.
Only brother killed in World War II.
Has outlived husband and both sons.

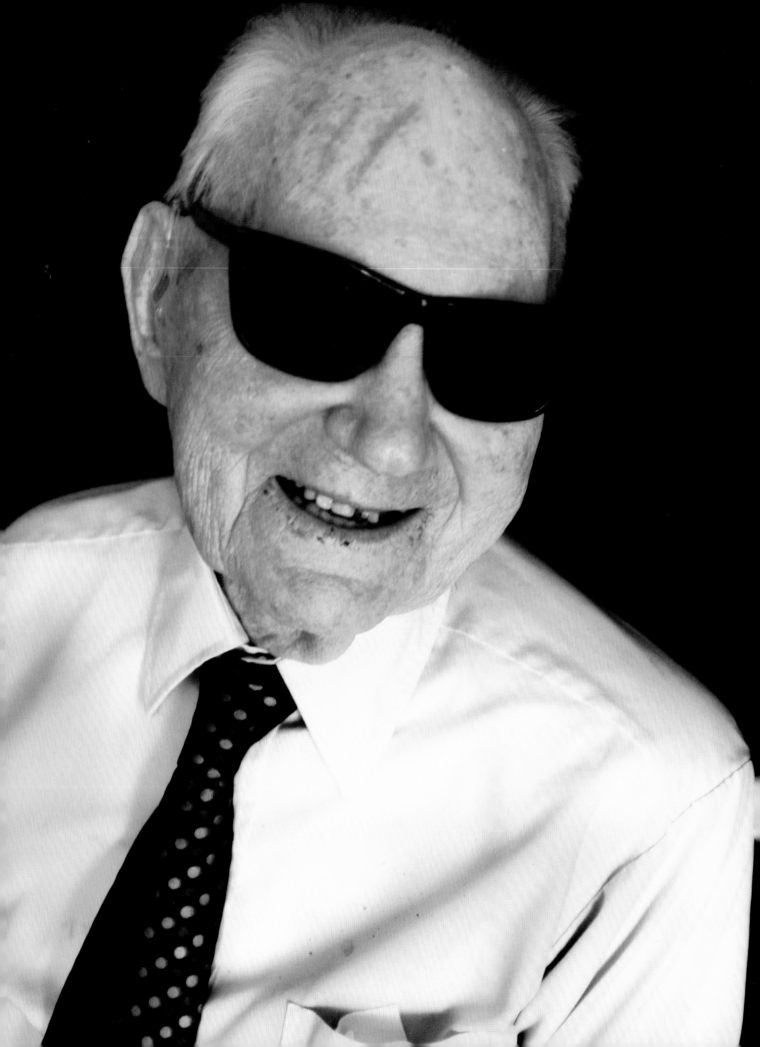

I had an urge to try and get along in the world. It used to be the only recourse blind people would have is stand on a street corner with a tin cup, and that didn't appeal to me at all. I've had a wonderful life.

All I can say is never give up. Never give up.

George Robert "Bob" Qualls, age 103
Enid, Oklahoma

Born April 11, 1903 in Savannah, Tennessee.
Photographed October 9, 2006 in Enid.
Blinded in Comanche County farm accident at age 10.
Master's degree in English and dramatics from Texas Christian University.
Post-graduate work in drama at Boston's Curry School of Expression.
Piano tuner for more than 80 years; now semi-retired.
Survived colon cancer surgery in 1990; now battling prostate cancer.

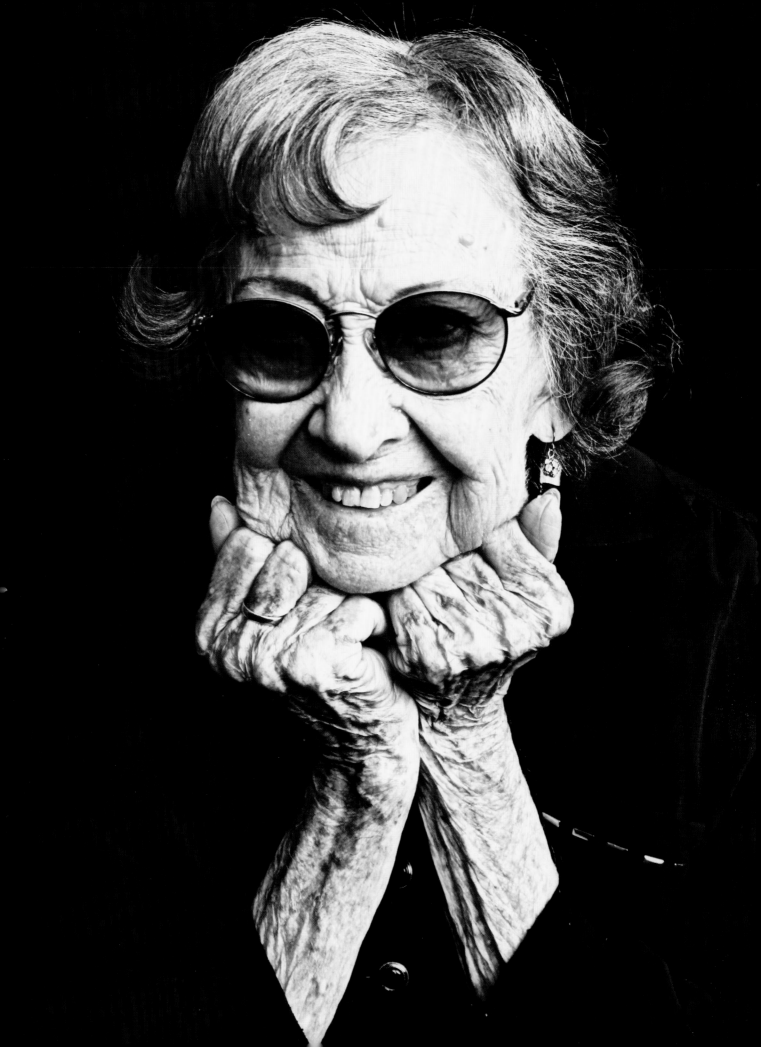

I just loved working. I'd work today, if they'd let me!

Gladys Nona Meeks Owens, age 99
Ardmore, Oklahoma

Born January 6, 1907 near Springer, Chickasaw Nation, I.T.
Photographed August 19, 2006 in Ardmore.
Former postmaster in Springer, Oklahoma.

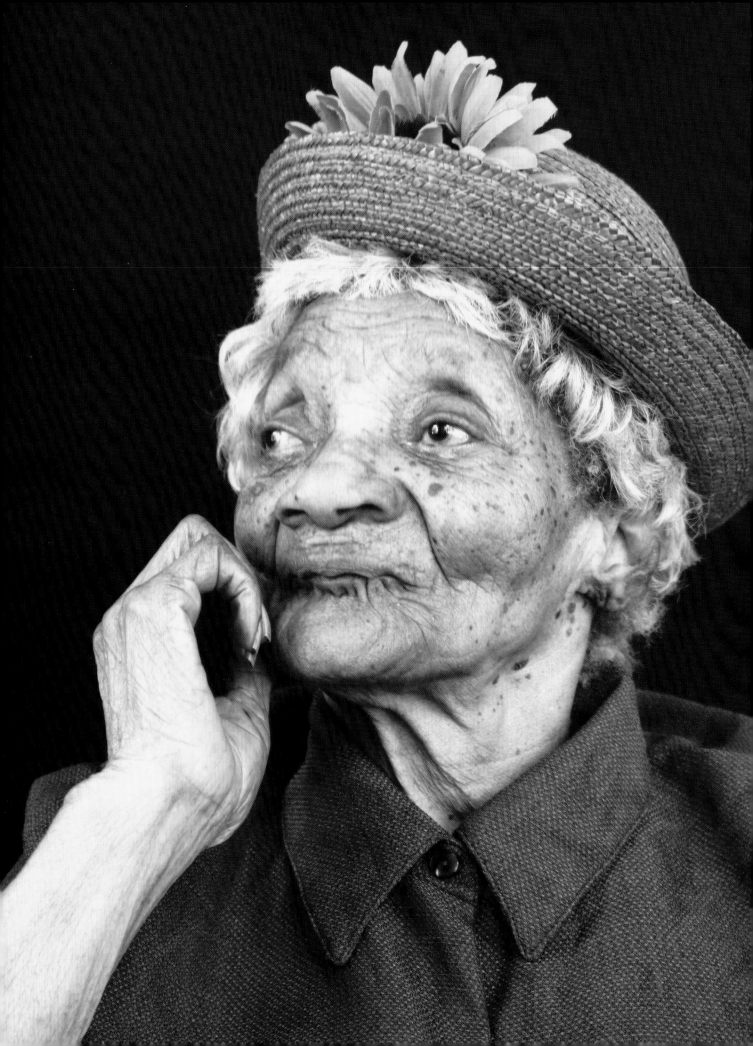

Just keep on living, child.

Ruby Lee Kornegy Dobbs, age 100
Oklahoma City, Oklahoma

Born January 31, 1906 in Friars Point, Mississippi.
Photographed August 7, 2006 in Oklahoma City.
Worked as a maid in private residences in Oklahoma City.
Famed for pies she baked for family and church events.

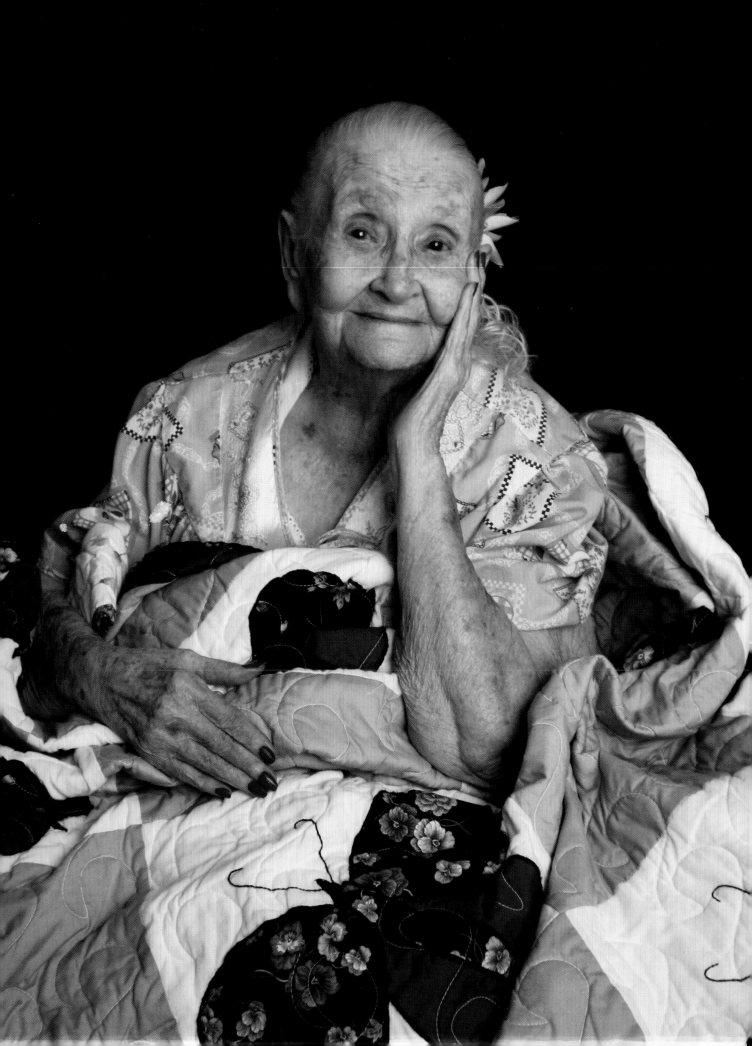

Do as I do.

Zelious Richards Miller, age 103
Miami, Oklahoma

Born February 21, 1904 in Rome, Missouri.
Photographed February 27, 2007 in Miami.
Made nine-day trip from Missouri to Oklahoma by covered wagon at age 8.
Mother of five sons, creator of hundreds of quilts.
Pictured with her favorite quilt, which she hand stitched.
Father lived to 99, grandfather to 100, great-grandfather to 104.

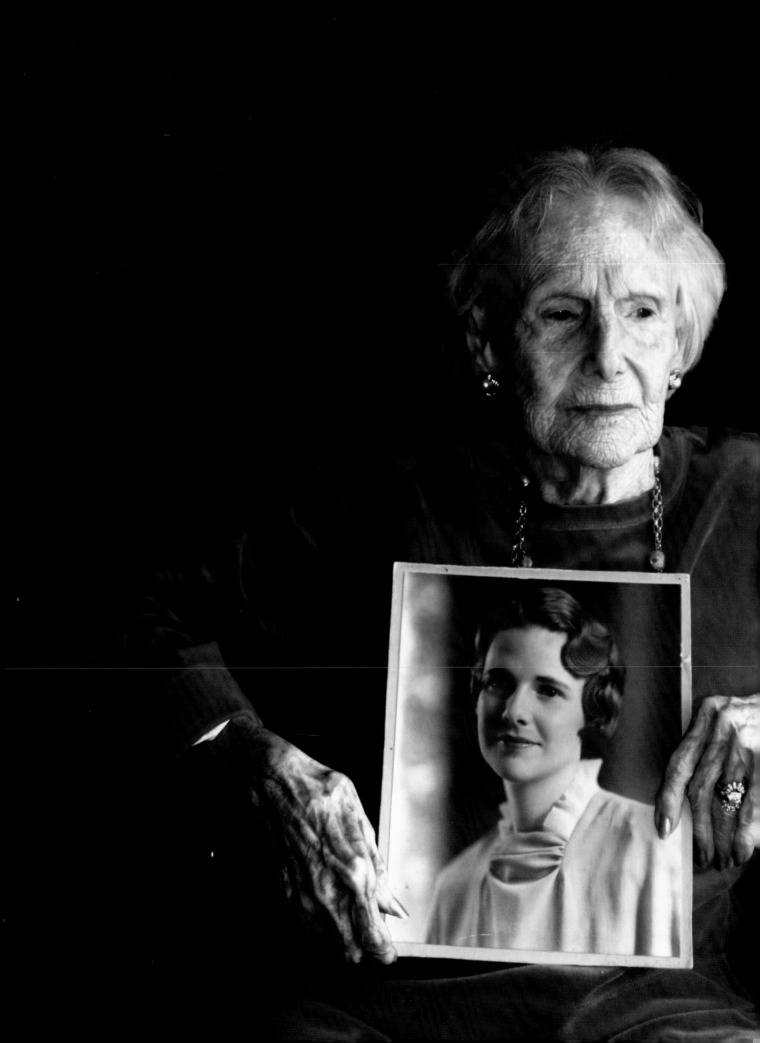

Who in the hell wants to be 100 years old anyway?
Look on the bright side of things instead of the gloomy side.
Make your own fun.

Marian Harrison Weimer, age 98
Tulsa, Oklahoma

Born August 18, 1907 in Milton, Florida.
Photographed May 23, 2006 in Tulsa.
1926 Kappa Kappa Gamma Queen.
Voted One of Five Most Beautiful at the University of Oklahoma.

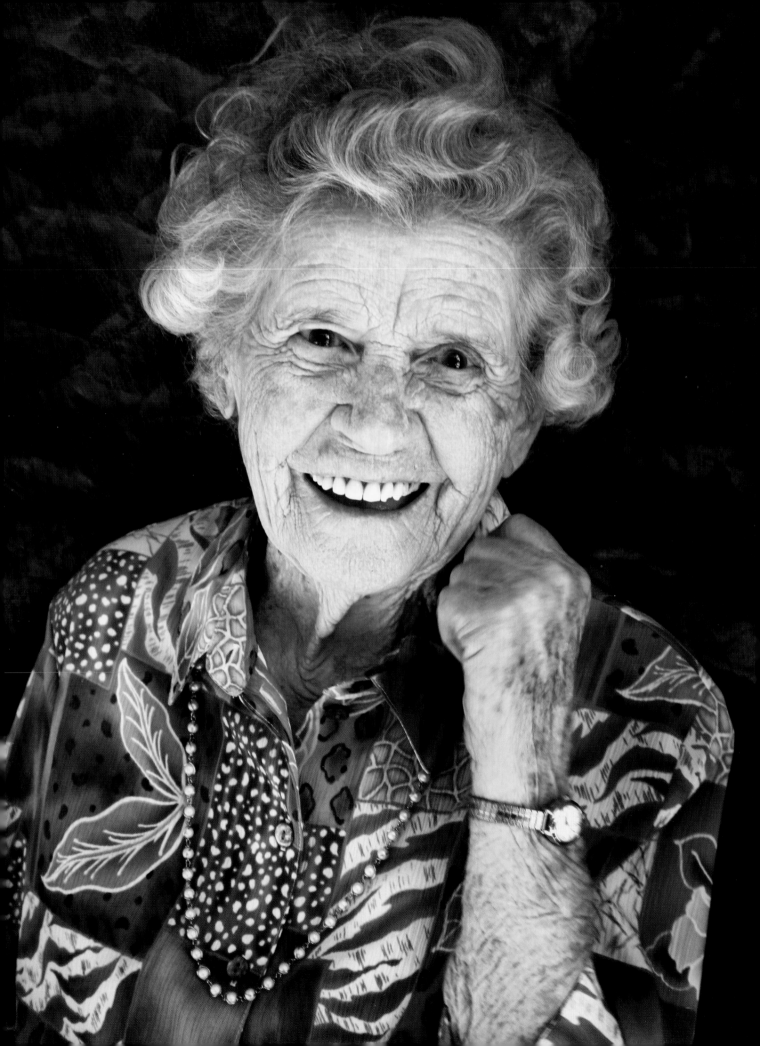

I'm a happy person, happy and contented. I live in a six-room house, live all alone and take care of everything. I go anywhere I want to go, and eat anything I want to eat.

I take life easy, take it as it comes. I enjoy EVERY day. Every day!

Ida Lee Sykes Matheny, age 102
Wewoka, Oklahoma

Born September 2, 1904 in Bush, Mississippi.
Photographed October 2, 2006 in Oklahoma City.
Moved to Oklahoma prior to Dust Bowl.

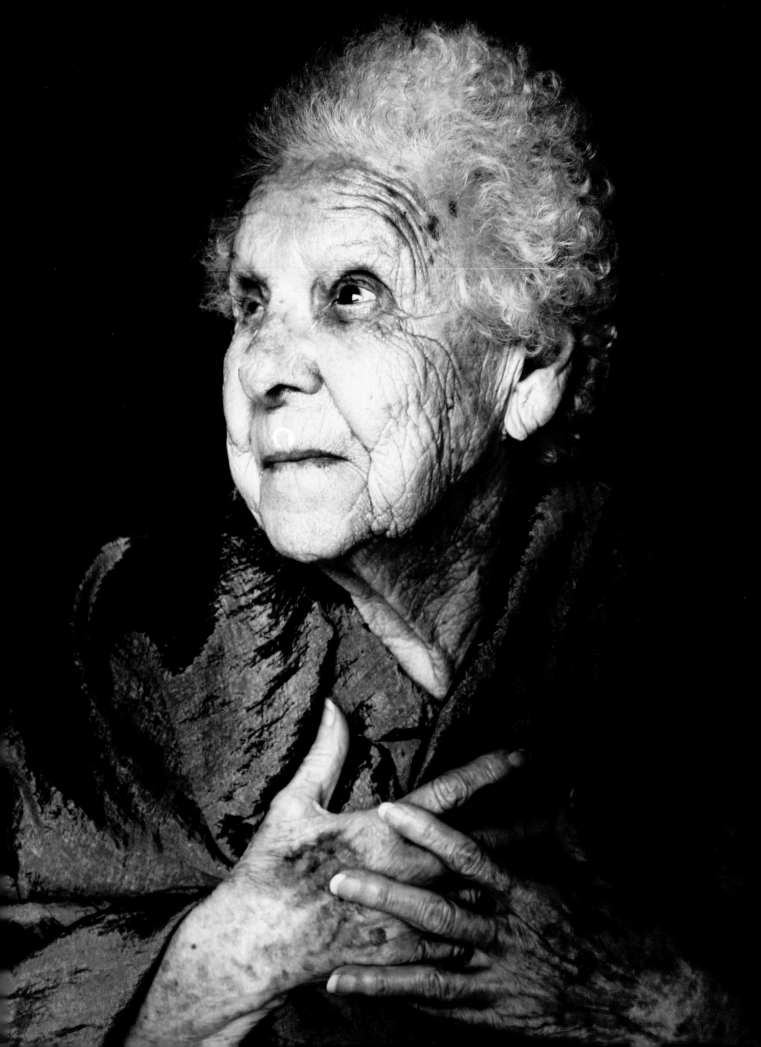

The days just pass.

Alma Quisenberry Morgan, age 102
Harrah, Oklahoma

Born February 25, 1904 near Hominy, Osage Nation, I.T.
Photographed August 18, 2006 in Harrah.
Father ran four spans of mules out of Catoosa.
World War II Gold Star Mother.
Both sons killed in action.

*Our secret to a
happy marriage?
He's the boss sometimes.
Sometimes he isn't.*

BERTHA NAOMI NALLEY ADAMS

Chapter V LOVE AND FAMILY

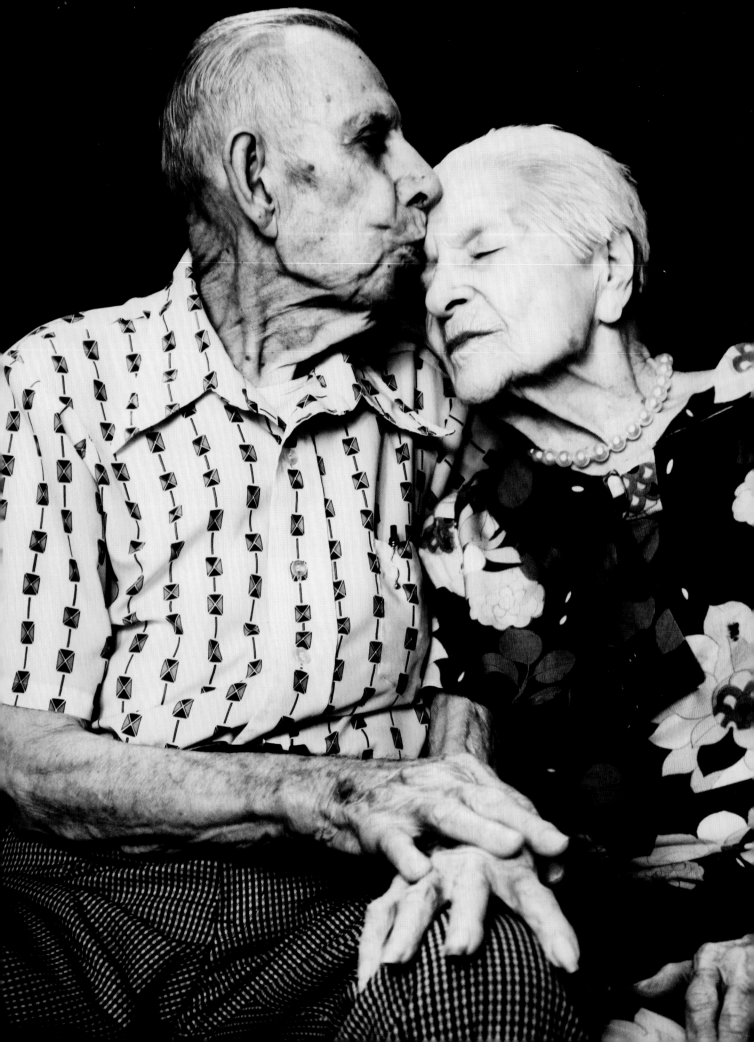

The Gowers

We never had any problems we couldn't agree on. It's very important to marry the right woman. If you had to do it over, would you marry me again?

John Haskell Gower, age 98
Ponca City, Oklahoma

Born September 9, 1907 in Cotton County, O.T.
Photographed August 10, 2006 in Ponca City.
Named for state's first governor.

Three or four times more.

Helen Vap Gower, age 103
Ponca City, Oklahoma

Born July 20, 1903 in Kildare, O.T.
Photographed August 10, 2006 in Ponca City.
Has made numerous quilts and more than 100 afghans.
Married 73 years to John Haskell Gower, who first dated her sister.

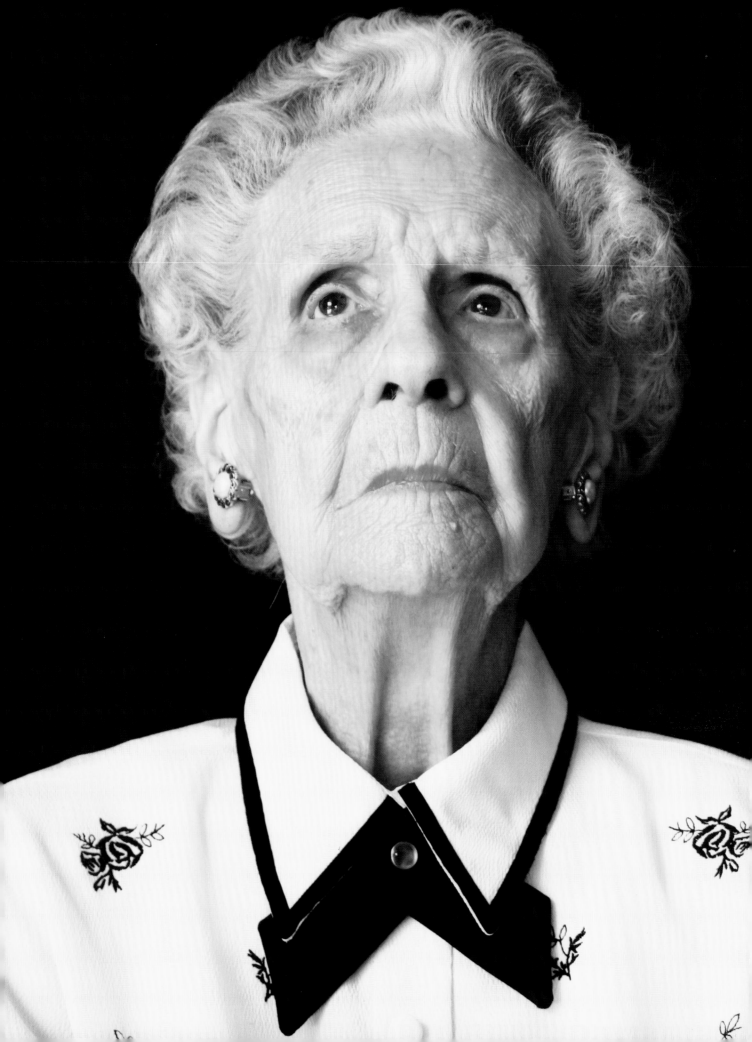

*I don't know if it's too personal to say, but I think the biggest
thrill I ever had was when I nursed my baby, Genevieve.
I could feel life going from me into her, and from her into me.
It was the biggest thrill.*

Edith Bean Hopkins, age 104
Enid, Oklahoma

Born December 28, 1901 in Plainville, Kansas.
Photographed August 11, 2006 in Enid.
Recalls Oklahoma's 1907 statehood celebration:
*Of course, I didn't know what it meant. I only knew they laughed and were just real happy.
I certainly remember.*

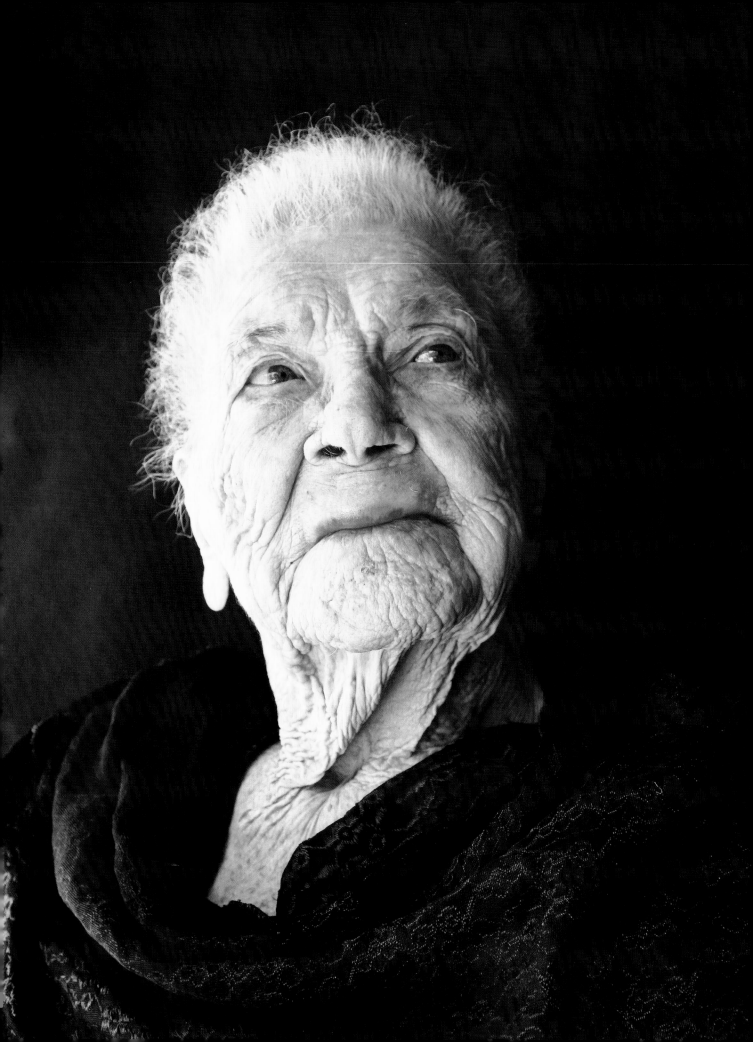

My mother had 13 children. We all took care of each other. When my little brother—he's 95 now—was a baby, I ironed his diapers, his T-shirt, his socks. I still love it. If I could, I'd iron everything in my house, starting with the pillowcases.

Ruby Lee Trammell Brewer, age 100
Rush Springs, Oklahoma

Born February 7, 1906 near Bailey, Chickasaw Nation, I.T.
Photographed June 24, 2006 in Rush Springs.
Original Chickasaw allotee.
Lives independently on her 1906 allotment.

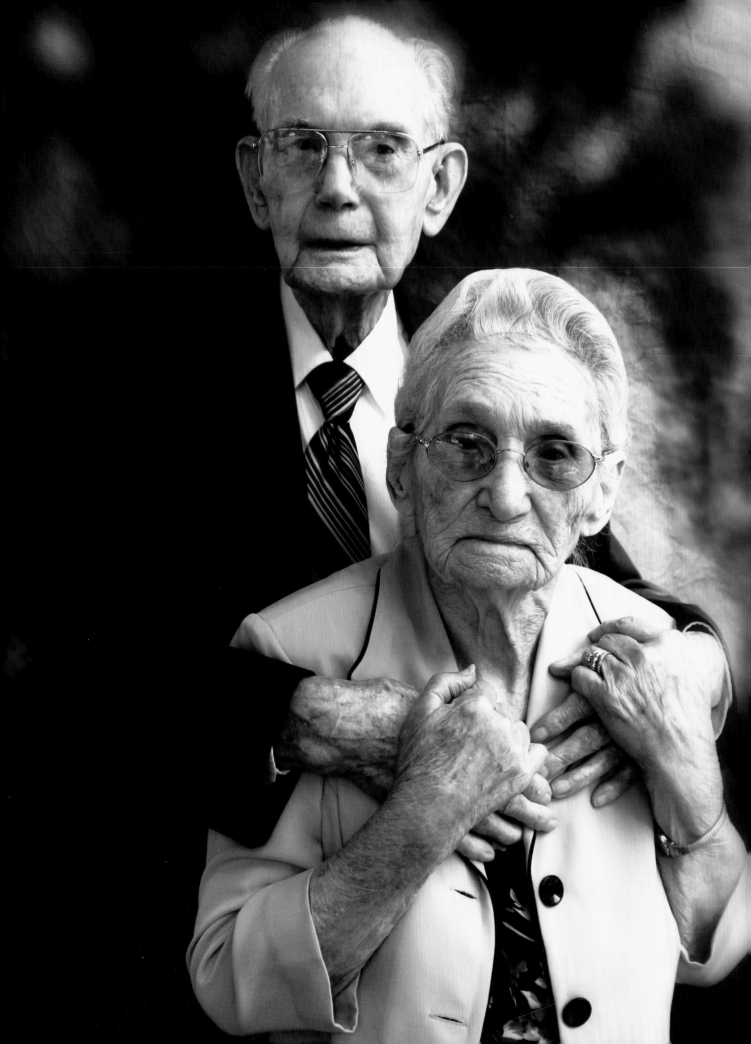

The Adamses

Our secret to a happy marriage? He's the boss sometimes.
Sometimes he isn't.

Bertha Naomi Nalley Adams, age 100
Pryor, Oklahoma

Born August 30, 1905 in Lead Hill, Arkansas.
Photographed May 12, 2006 in Pryor.
Never drove a car or flown in an airplane.
Foster mother "Nanny Bert" to more than 200 children.

I advise not to be in no trouble. No beer or whiskey.
And no smoking

Roy Alfred Adams, age 100
Pryor, Oklahoma

Born October 30, 1905 in Crocker, Missouri.
Photographed May 12, 2006 in Pryor.
Retired barber.
"Papa Roy," foster father to more than 200 children.

Married 80 years on July 18, 2007.

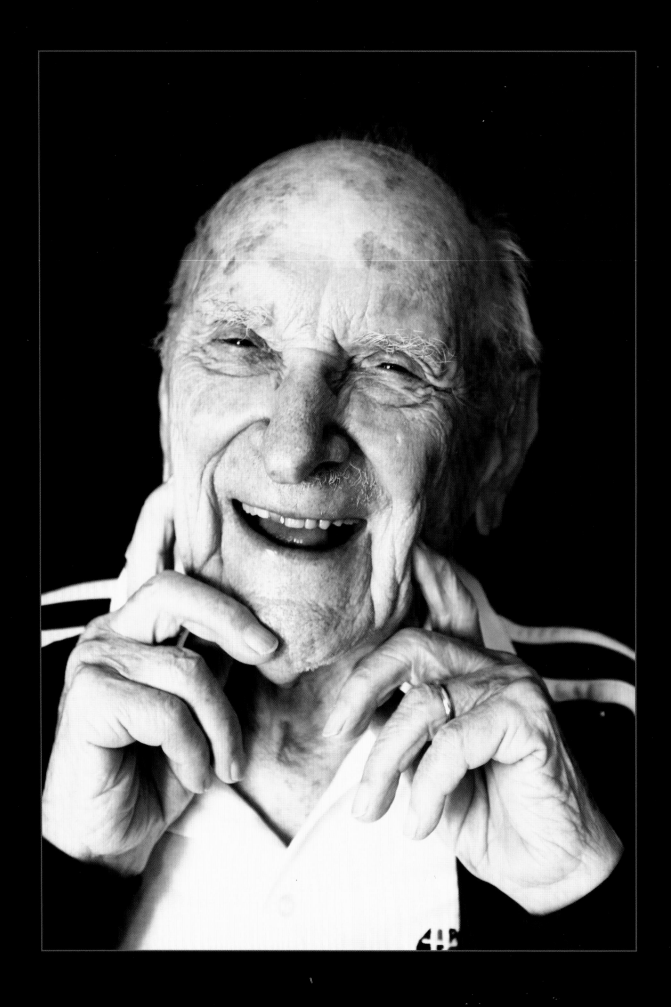

I was married 70 years. We had a big celebration in April, and she died in July. She had a stroke that affected her speech, but she could say one word – Leon – and get my attention.

Leon Matthews, age 101
Tulsa, Oklahoma

Born March 20, 1905 in Dallas, Texas.
Photographed June 16, 2006 in Tulsa.
Artist.

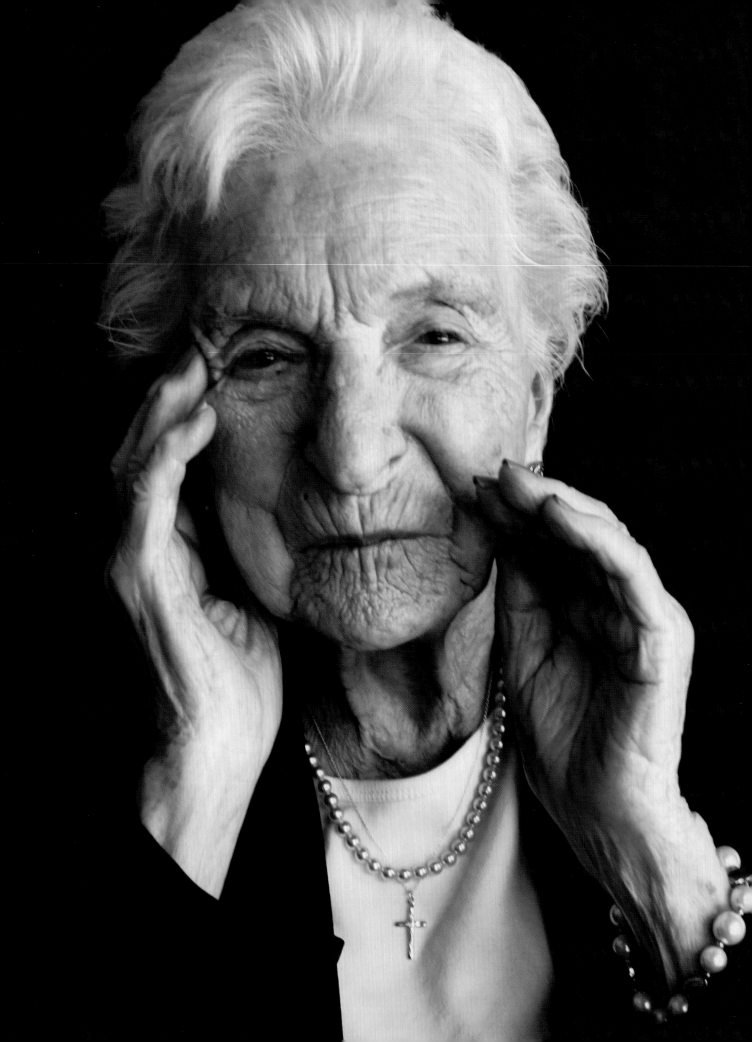

I was the oldest of eight, five boys and three girls. I was 17 when I married. The first thing I done, I bought me a new lipstick and had my hair bobbed off. I cried after I did it. I got married on a Saturday, and had my hair cut on a Monday. He was 19 when we married—an older man.

He died 51 years ago. My job is to be a survivor.

Nellie Adeline Miller Hutcherson, age 101
Oklahoma City, Oklahoma

Born August 13, 1905 in Sentinel, O.T.
Photographed January 26, 2007 in Oklahoma City.
World War II "Rosie the Riveter"—shot rivets in airplane wings and read schematics.

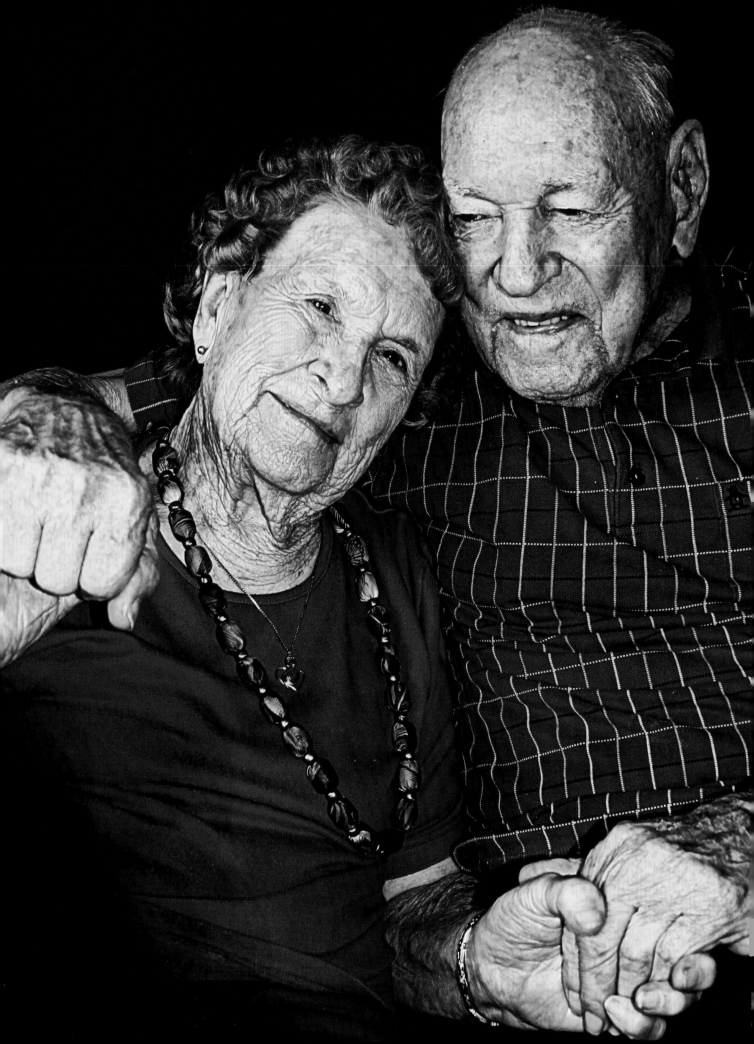

The Zacharys

HAL:

I will tell you now, I have not seen her equal in all these years.

MICKEY:

He was superintendent of schools, and I was a teacher. I said to him, 'Honey, the buck stops at your desk at school. At home, it stops at MY table.' He still has a remarkable memory. Sometimes I wish he wouldn't remember quite so well...

HAL:

Friendship is the best thing. You must be friends. It's a sense that's deep. It's earned. First it was friendship and then it was companionship, marriage and compromise.

MICKEY:

I can't imagine not having him. Our graves are side by side. We'll rest that way. Whatever eternity is, we'll be there.

HAL:

Together.

Mildred "Mickey" Campbell Zachary, age 99
Cement, Oklahoma

Born March 21, 1907 in Coffeyville, Kansas.
Photographed August 17, 2006 in Chickasha.
Married June 1, 1929.

Leroy Holland "Hal" Zachary, age 100
Cement, Oklahoma

Born August 5, 1906, in Cement, O.T.
Photographed August 17, 2006 in Chickasha.
Traveled with Mildred more than 100,000 miles by motor home after retirement, before losing sight.

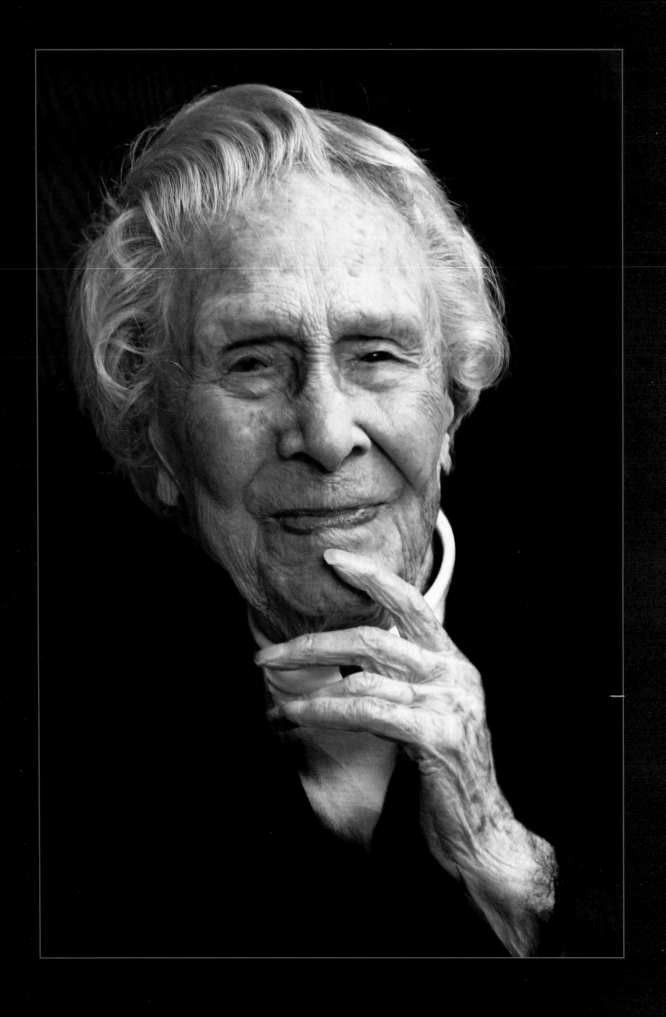

I was payroll clerk for the Supreme Court, and he was elected judge from Muskogee. His office was right across from mine. He had just bought a new car, a Buick, and asked me if I wanted to take a ride.

Well we ended up married, and I lost my job. But it was worth it.

Daisy Hawley Blackbird, age 103
Oklahoma City, Oklahoma

Born January 18, 1903 in Tupelo, Chickasaw Nation, I.T.
Photographed September 13, 2006 in Oklahoma City.
Original Chickasaw allottee.
Second oldest of 10 children.
Widow of Oklahoma Chief Justice W.H. Blackbird.

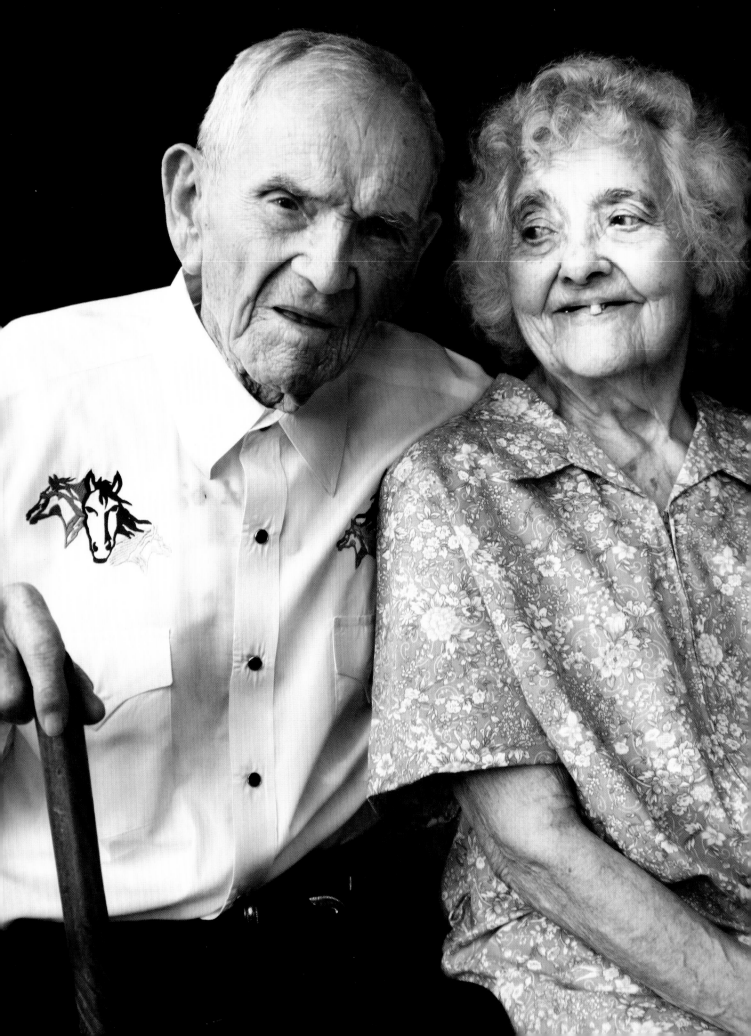

The Blackard Siblings

I never dreamed about being over 100 years old.
I know my time is getting short, getting near the end.
I had a good life. I enjoyed it.

DeWitt Frank Blackard, age 103
Valliant, Oklahoma

Born May 7, 1903 in Potts Camp, Mississippi.
Photographed August 9, 2006 in Valliant.
Pilot.
Alaskan gold miner.
California shipyards worker.

Growing up with 10 other children, we had to work together.
We weren't allowed to fuss. So we grew up helping each other,
and laughing.

Eunice Lucille Blackard Raiford, age 101
Valliant, Oklahoma

Born March 15, 1905 in Potts Camp, Mississippi.
Photographed August 9, 2006 in Valliant.
With brother Frank, Oklahoma's oldest siblings.
Father lived to 101, mother to 99.

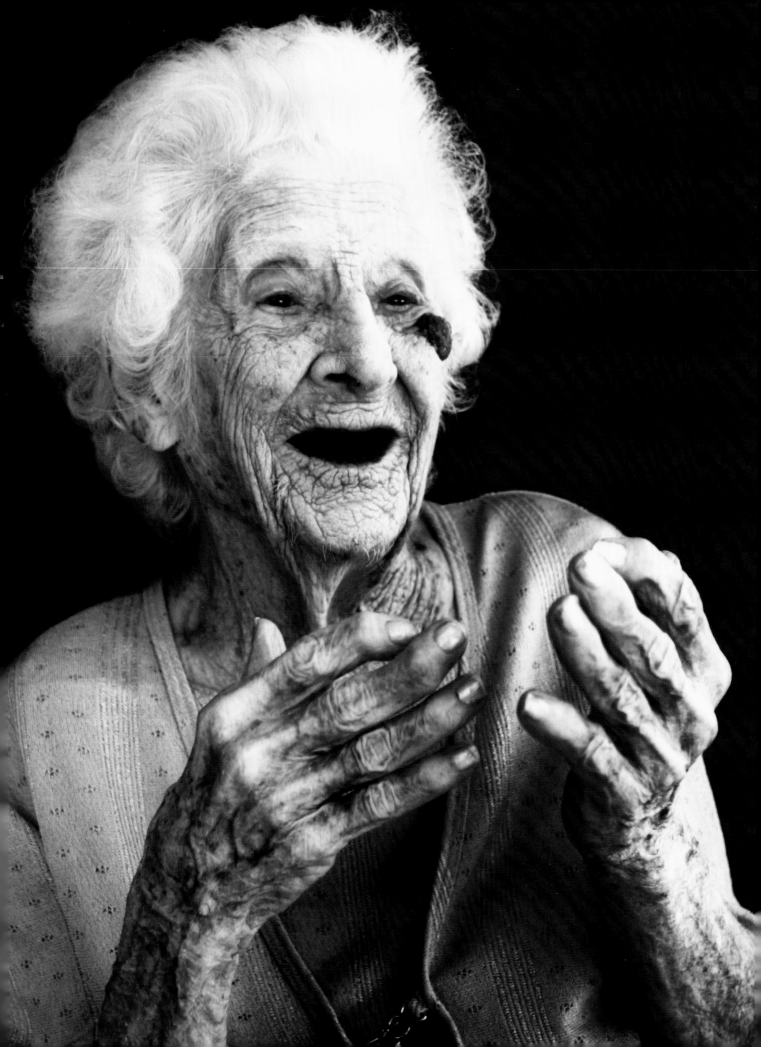

*I remember begging my daddy to let me try to ride a wild horse
we saw near our place. He said I'd break my neck, not the horse.
He finally let me. I was only about 8 years old, but I did a good job.*

I loved that horse. I named her Blaze.

Olive "Tootie" O'Neal, age 102
Commerce, Oklahoma

Born April 30, 1904 in Lane, Kansas.
Photographed June 9, 2006 in Commerce.
Brother coined her nickname when he couldn't yet pronounce "Cutie."

Be happy! Keep busy!
Be friendly!

LUCILLE HOLMAN WOODEN

Chapter VI **ADVICE**

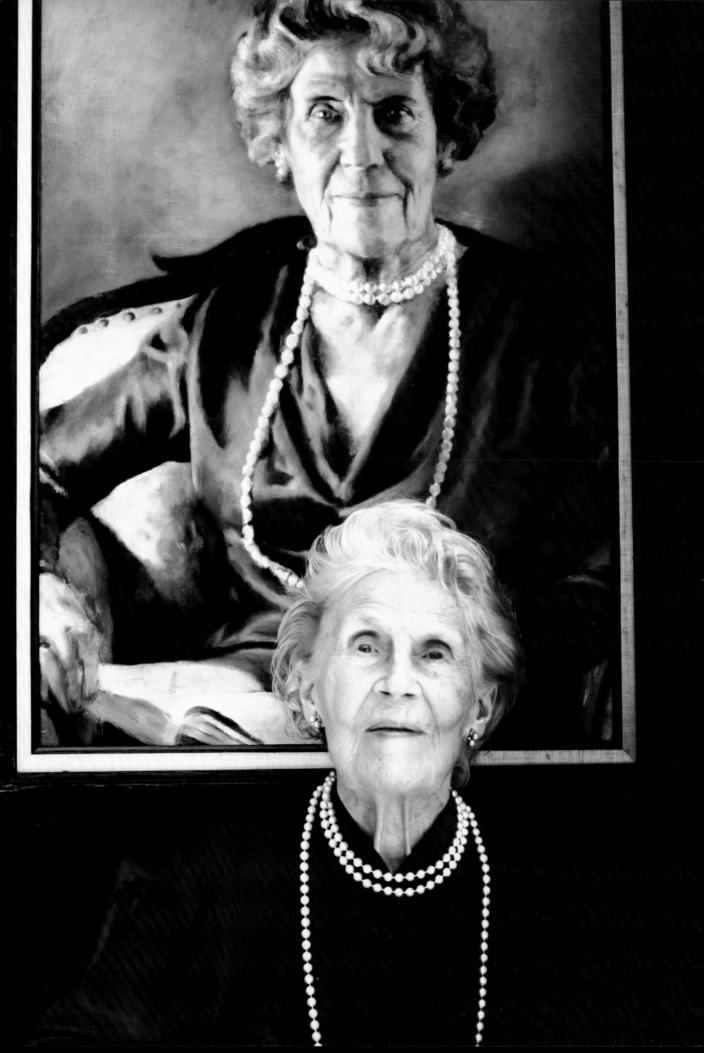

Getting more out of life may be as simple as giving more.

Alice Allen Everett, age 102
Oklahoma City, Oklahoma

Born November 10, 1903 in Holden, Massachusetts.
Photographed May 17, 2006 in Oklahoma City.
Co-author of medical books with late husband, Dr. Mark R. Everett, Dean of University
 of Oklahoma Medical School.

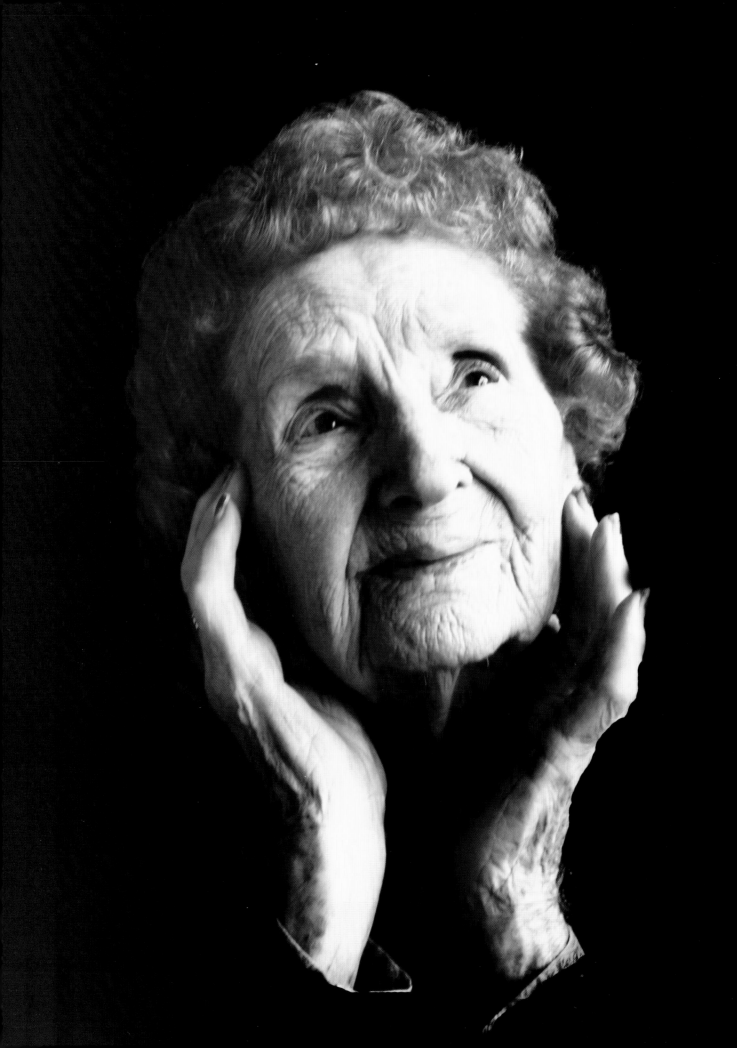

Get a good education. Education should be prominent and foremost, never to be put aside. And I think that's all right.

Leola Marie "Babe" Siler Schnorr, age 99
Tonkawa, Oklahoma

Born February 9, 1907 in Ceres, O.T.
Photographed August 10, 2006 in Tonkawa.
Born into a family of teachers.

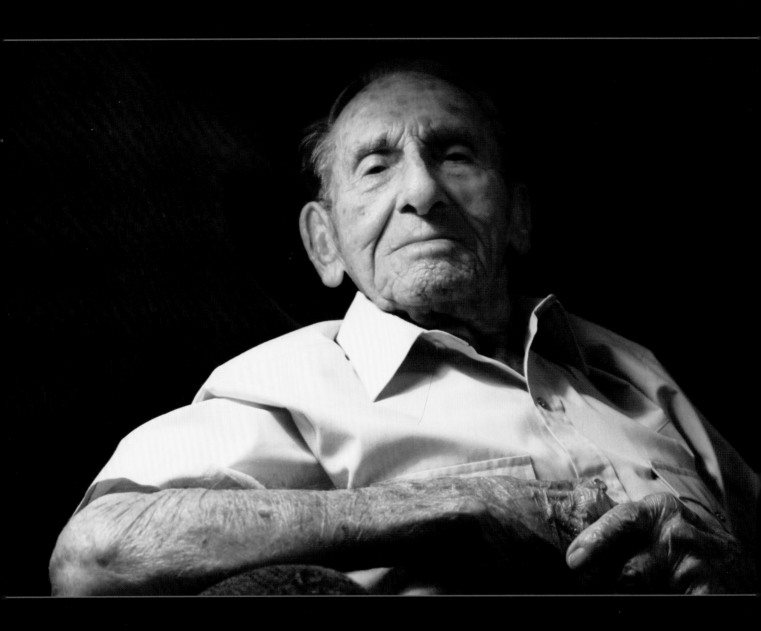

*Just try to be a good citizen. If they elect you to something,
you do it. I was on the soil conservation board, the school board,
the church board. Don't want to hurt the world any.*

Harold Oscar Kuehny, age 98
Blackwell, Oklahoma

Born December 7, 1907 near Deer Creek, O.T.
Photographed August 10, 2006 in Blackwell.
Cattle, grain, and wheat farmer.

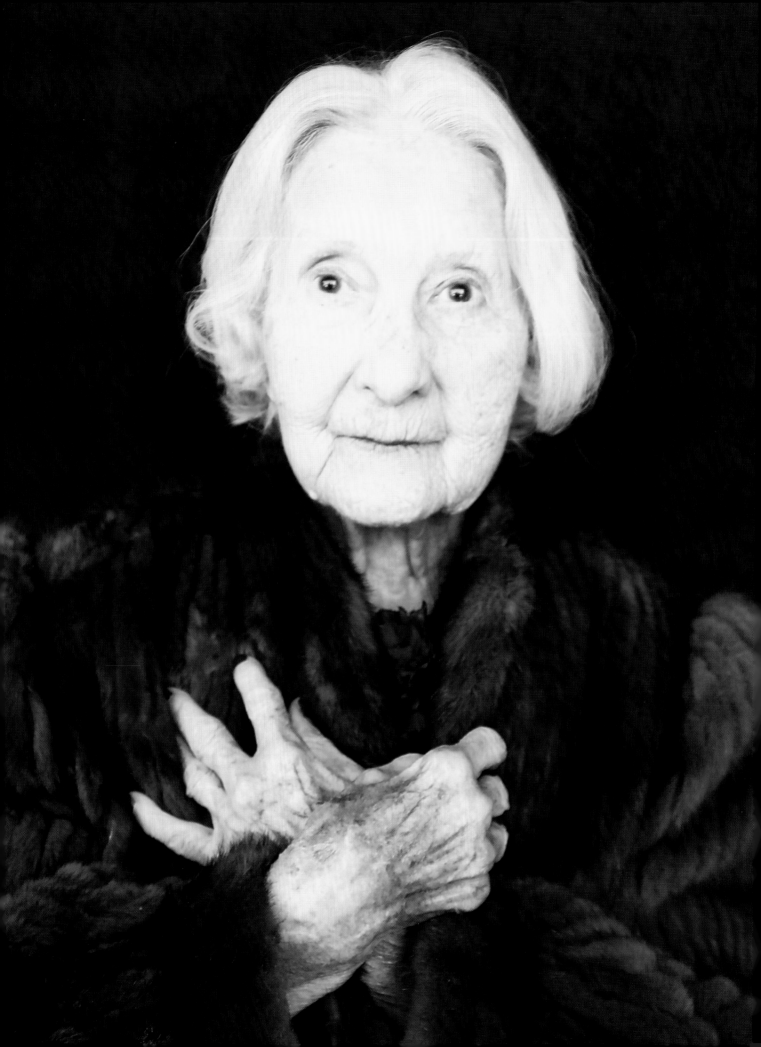

Always tell the truth.

Rose Agnes "Sudie" Musgrove Clevenger, age 99
Tulsa, Oklahoma

Born July 10, 1907 in Fairfax, O.T.
Photographed November 16, 2006 at Oklahoma Centennial kickoff, Tulsa.
Osage/French heritage.

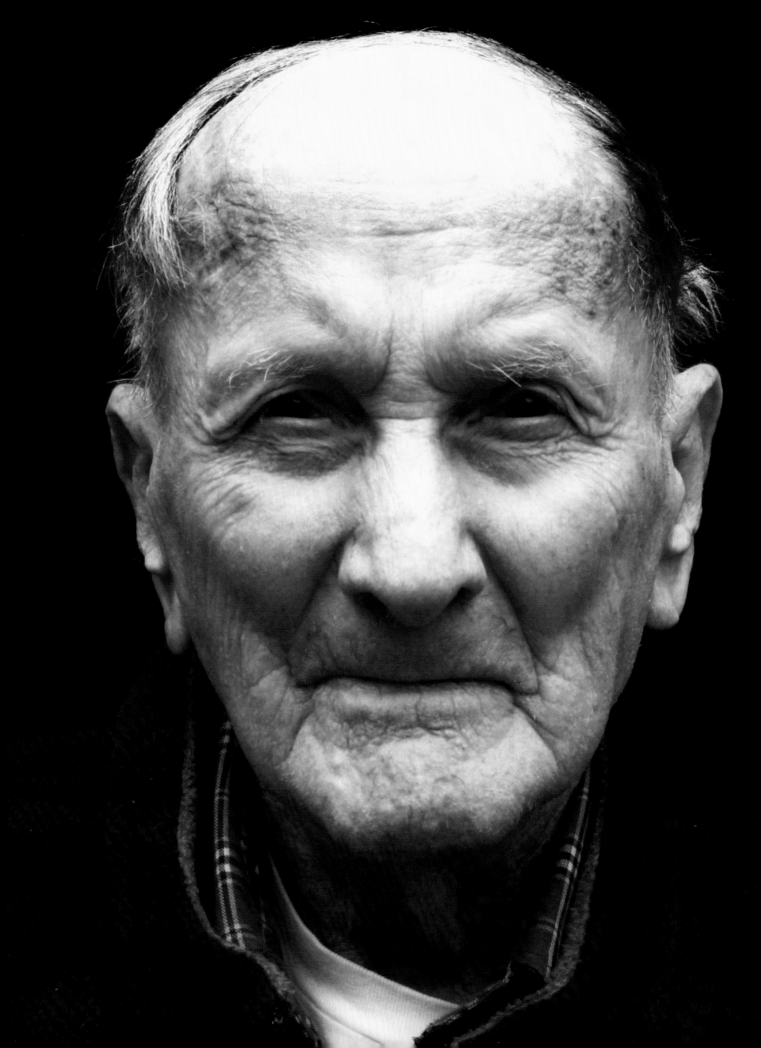

My advice? Eat lots of tomatoes.

John Howard Council, age 100
Heavener, Oklahoma

Born February 24, 1906 in Hartford, Arkansas.
Photographed May 1, 2006 in Tulsa.
Lifetime Mason.
Retired owner, Western Auto.

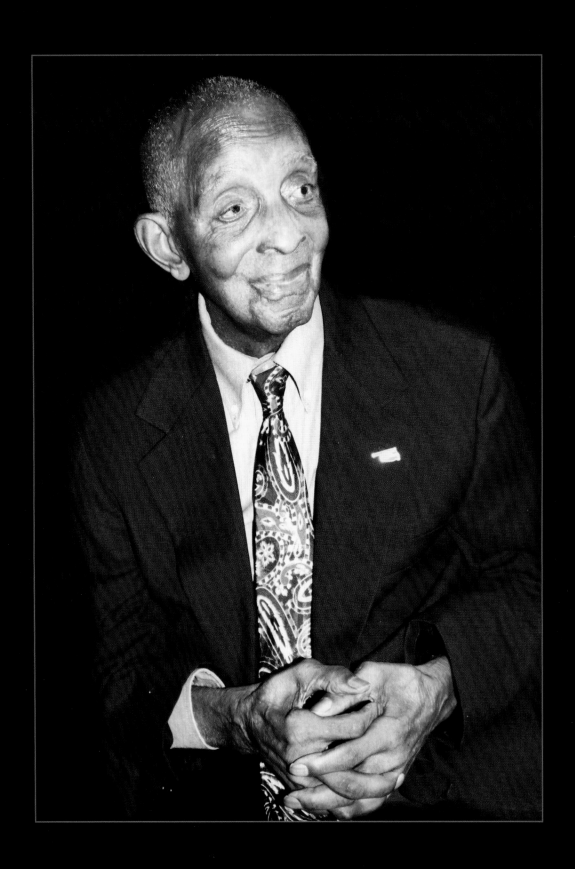

When opportunity knocks, we should be prepared to answer.
Many times the opportunity is not the path we were thinking of,
but it proves to be the best one.

My first experience with the so - called Jim Crow Law was in
Tulsa when I was not allowed in the State Rural Letter Carriers'
meeting in session at The Mayo Hotel.

James P. Owens, age 101
Okemah, Oklahoma

Born October 11, 1904 in Ashdown, Arkansas.
Photographed August 9, 2006 in Okemah.
Clearview, Oklahoma, rural letter carrier for 47 years (1927-1974).
Elected state delegate to 21 National Rural Letter Carrier Conventions.

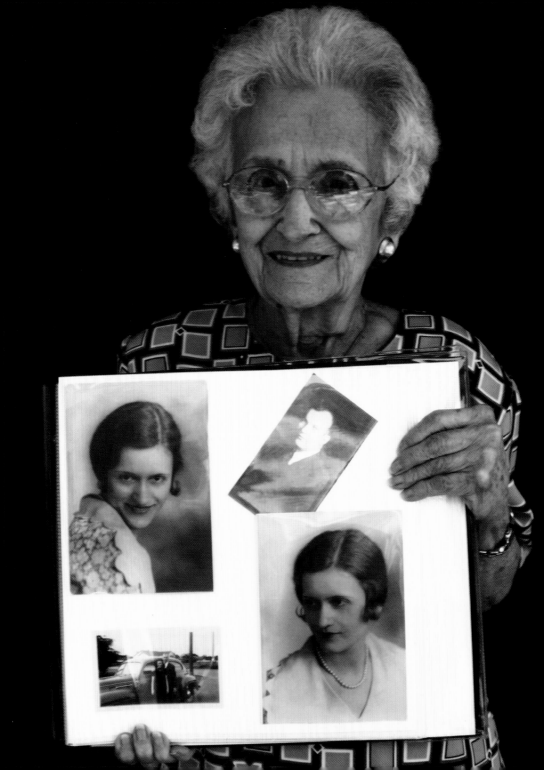

Don't fret and don't worry, it doesn't pay.
Just live life and love it from day to day.

Thelma Leone Swisshelm Hopkins, age 100
Tulsa, Oklahoma

Born March 14, 1906 in Berrysville, Ohio.
Photographed May 12, 2006 in Tulsa.
Poet.
Former Dictaphone operator for NCR.
Worked at Tulsa Flea Market until age 98.

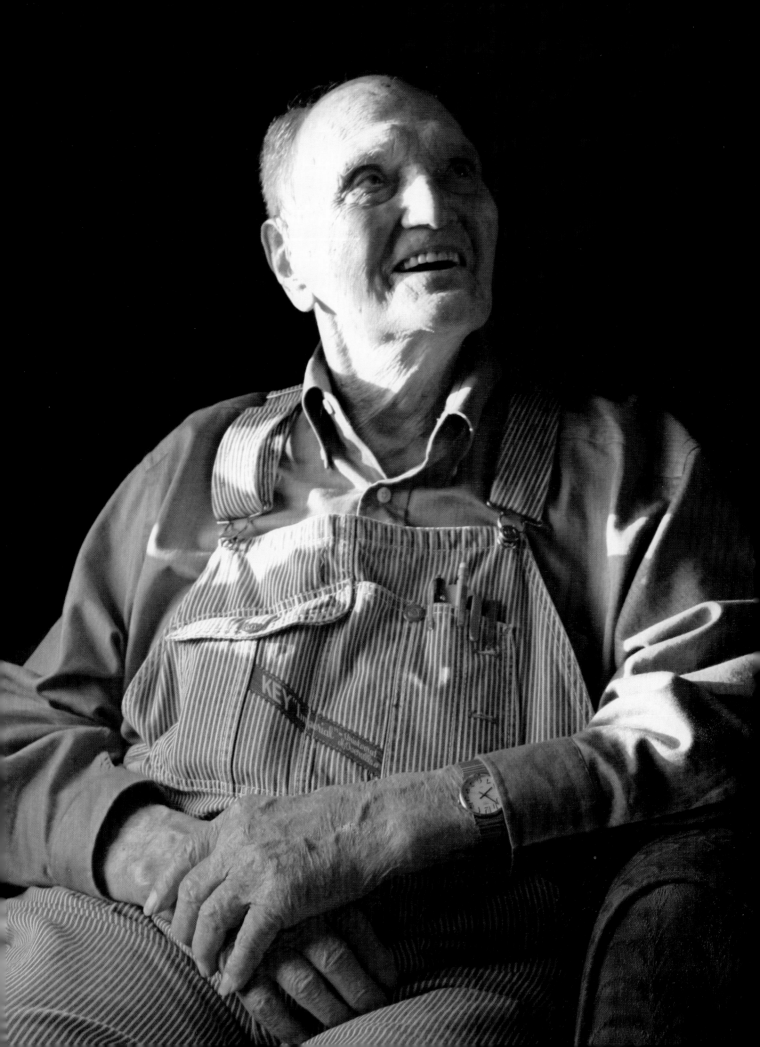

Young people getting married should take their vows seriously.
Children would have a better start and we'd have less trouble.
I hate to be a prophet, but my prediction is they'll have problems.

Walter John Dobrinski, age 99
Okeene, Oklahoma

Born January 16, 1907 near Hitchcock, O.T.
Photographed August 11, 2006 in Okeene.
Met his wife, Henrietta Alexine Drebenstedt, when he came across her and a friend trying
 to kill a chicken for supper. He took the ax and chopped off its head.
Married 61 years.
Father of 10.
Youngest child born in 1959.

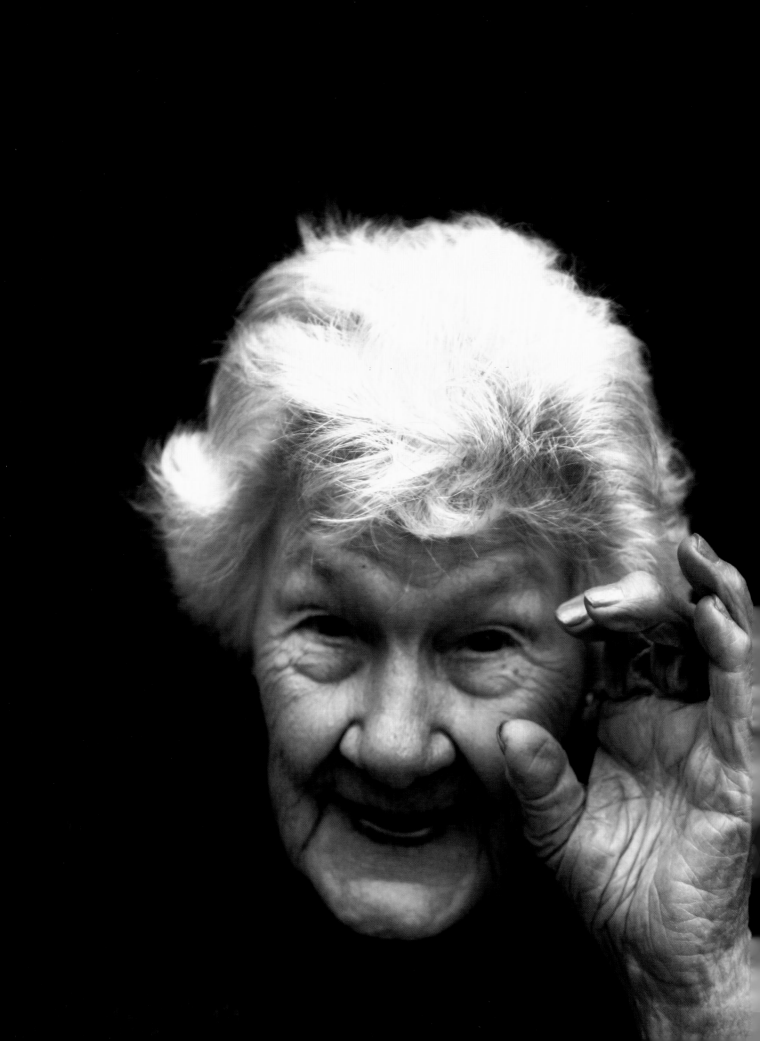

Live right, and eat good things.

Nora Owens Reed Simmons, age 101
Tulsa, Oklahoma

Born July 27, 1904 in Benton County, Arkansas.
Photographed May 1, 2006 in Tulsa.
One of 10 children.
Mother of eight, stepmother of six.
Her second husband is son-in-law's father.

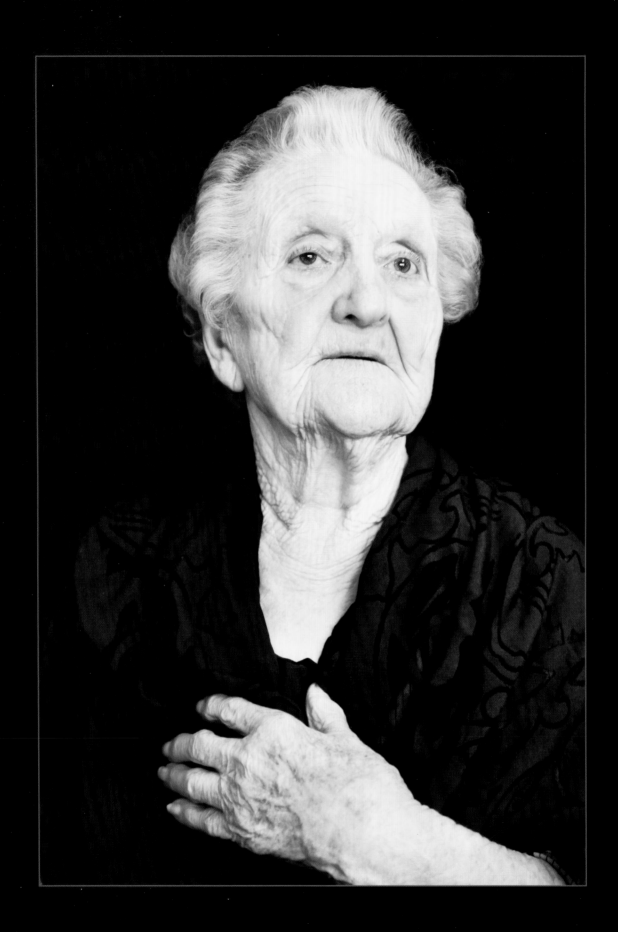

My advice is to be honest. That's about all it takes. If you're honest, you're honest about everything.

Marushka "Mollie" Rusch Bouse, age 99
Okeene, Oklahoma

Born September 2, 1907 in Overdoc, Russia.
Photographed August 11, 2006 in Okeene.
Family emigrated from Germany to Russia when Catherine the Great married czar.
Remembers clinging to mother's skirt during six-week crossing to United States.

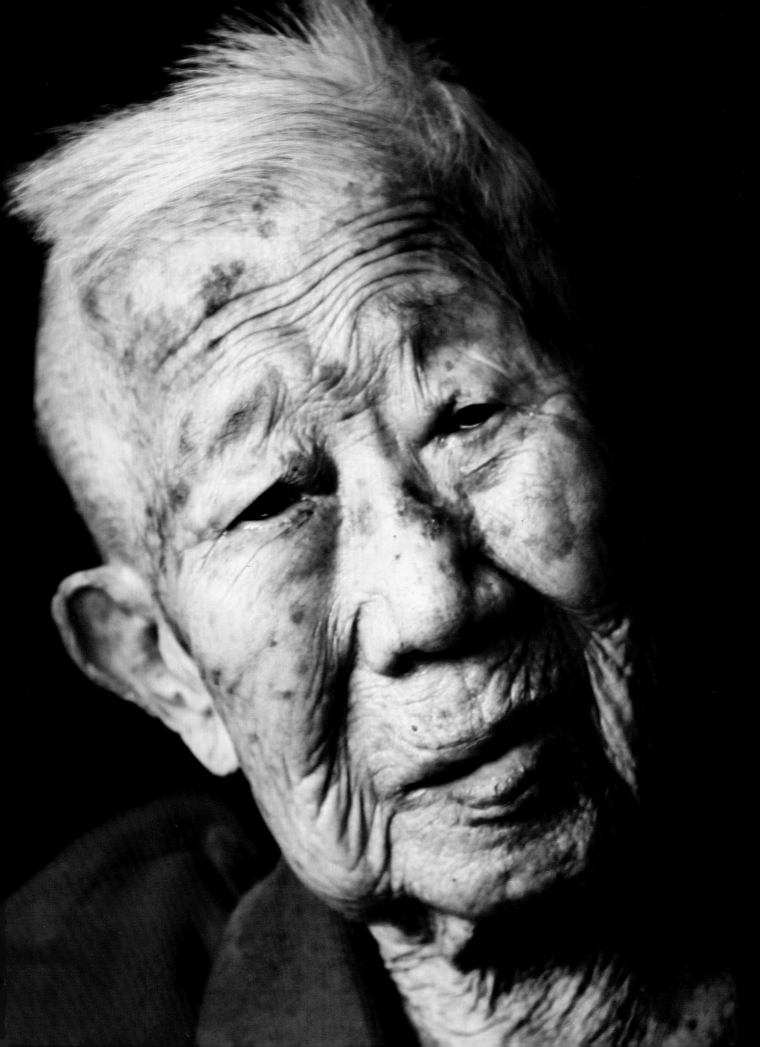

Be thankful for this government. Thank you for this government.

Meng Jo Chung, age 102
Tulsa, Oklahoma

Born July 29, 1903 in Tagu, Korea.
Photographed June 19, 2006 in Tulsa.
Immigrated to Oklahoma in 1983.
Matriarch of family with seven MDs and Ph.Ds.

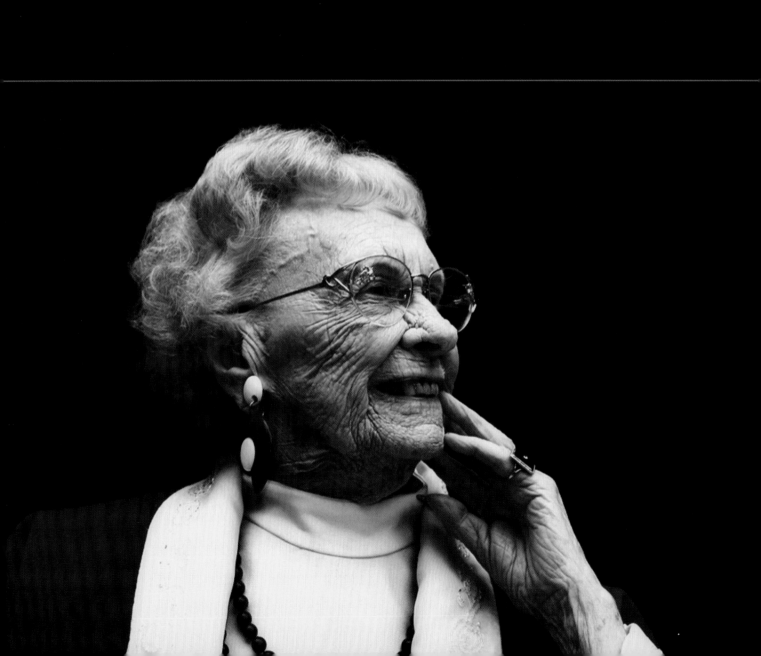

Be happy! Keep busy! Be friendly!

Lucille Holman Wooden, age 100
Tulsa, Oklahoma

Born July 10, 1905 in Norborne, Missouri.
Photographed May 1, 2006 in Tulsa.
Self-described professional volunteer.

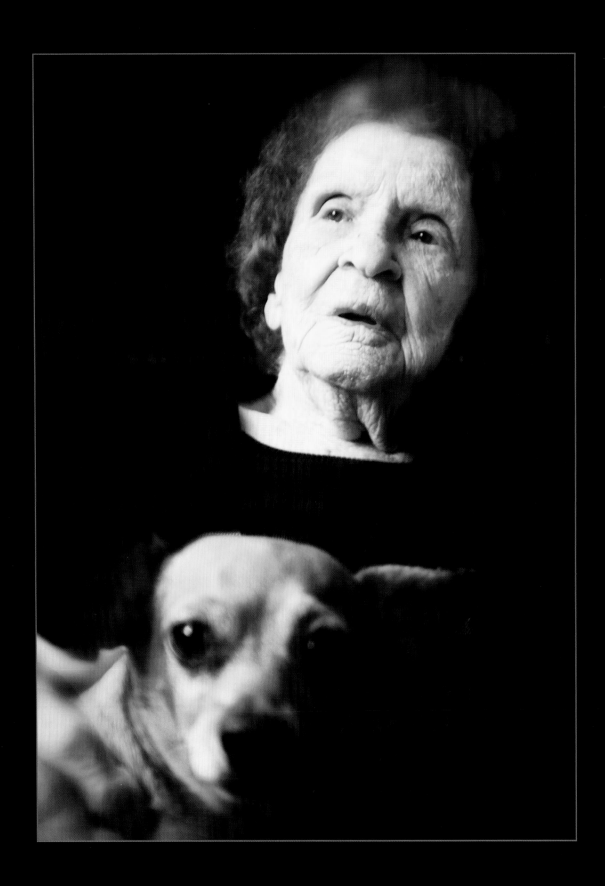

I used to have a lot of advice, but anymore I don't.

I set here and look out the window. I see pretty good for 100.

Juanita Pearl Richardson Lance Allen, age 100
Hartshorne, Oklahoma

Born October 21, 1906 in Hartshorne, Choctaw Nation, I.T.
Photographed January 27, 2007 in Yukon.
Choctaw Tribal member.
Pictured with Chi-Chi.

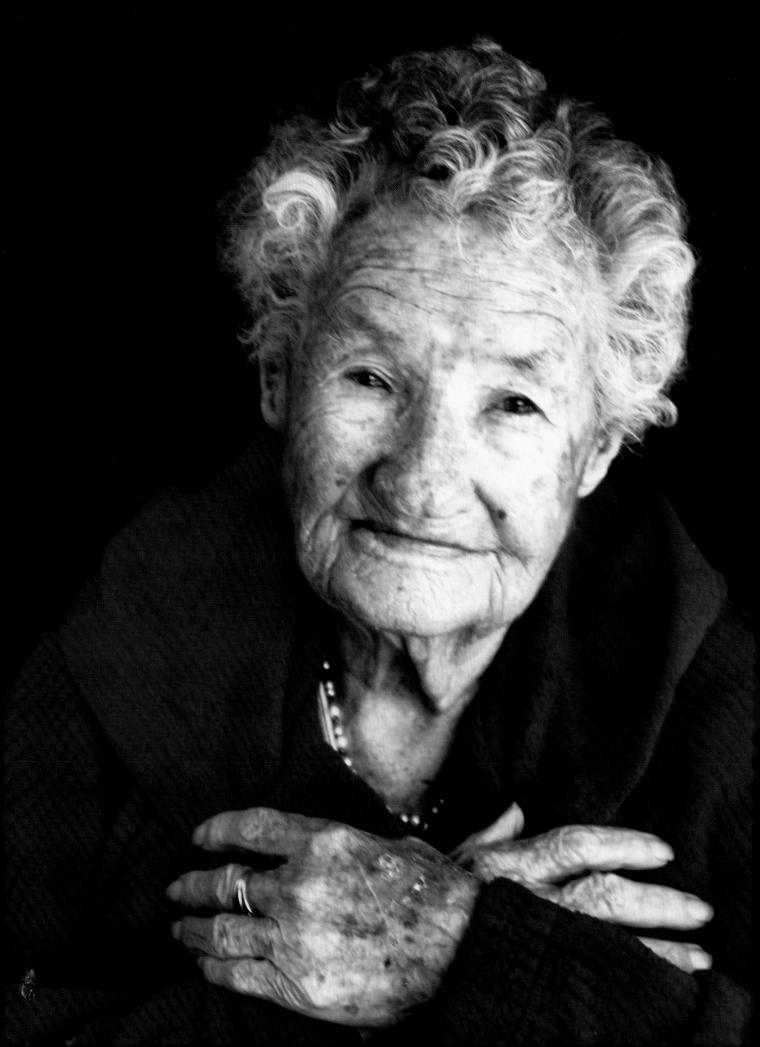

My advice? Live in Oklahoma!

Ada Harding Cheslic, age 102
Alva, Oklahoma

Born February 10, 1904 in Alva, O.T.
Photographed August 11, 2006 in Alva.
One of eight children, and mother of eight.
Kin to President Warren G. Harding.

I appreciate them all—
the ones that have done well,
and those that have done
the best that they could.

EVA LOUISE GALLIMORE BOYD

Chapter VII ON TEACHING

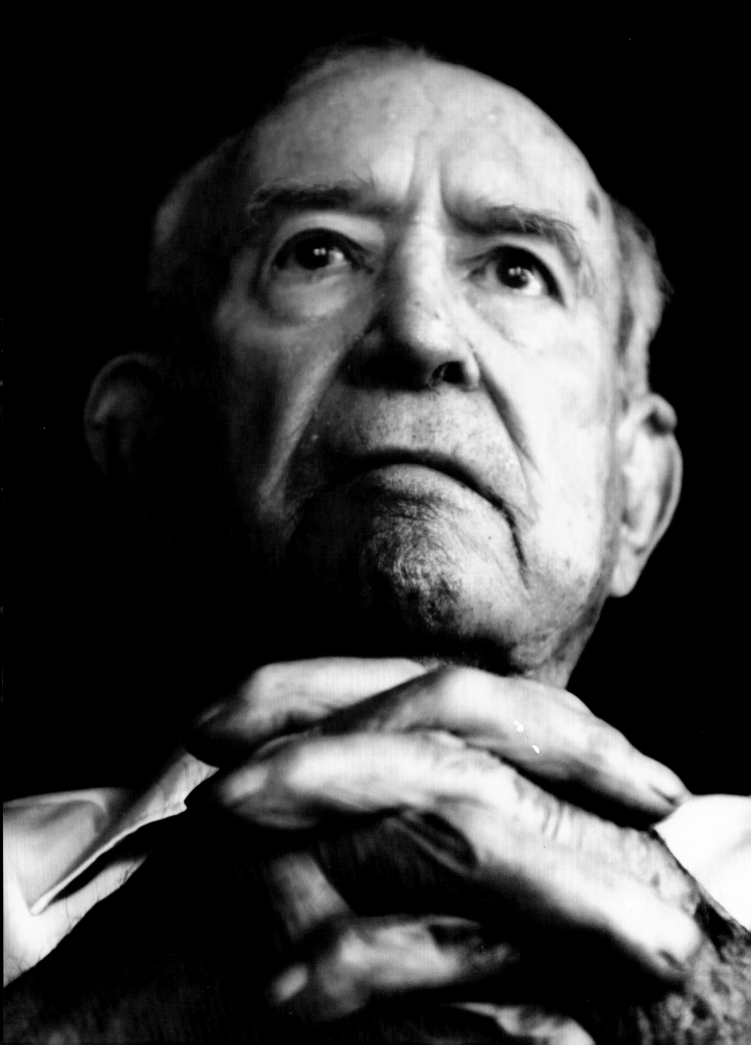

My wife was very smart. She was a teacher, too, and typed all my papers at Columbia and Duke. She should have had advanced degrees. Back then, men got the credit and the honors and the women did all the work.

O.K. Campbell, age 100
Commerce, Oklahoma

Born May 16, 1906 in Custer County, O.T.
Photographed June 9, 2006 in Commerce.
Former state representative.
Retired USAF lieutenant colonel.
Ph.D from Duke University.

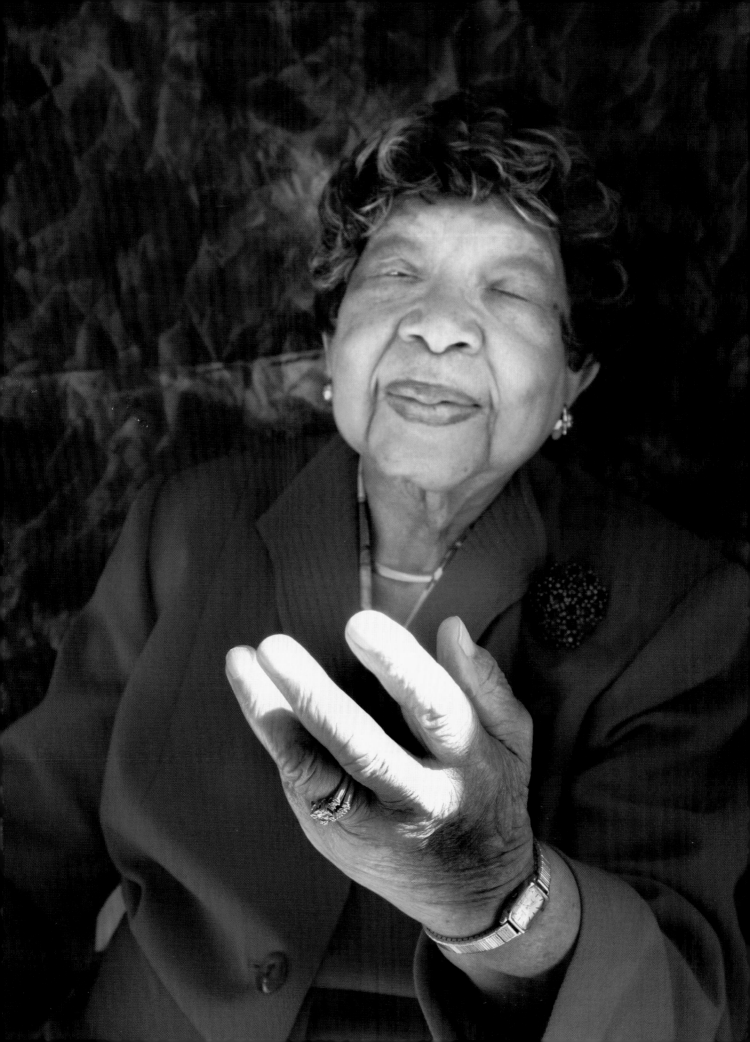

I taught music for 43 years. Every moment was a happy moment. I had the pleasure of touching the lives of my students. I appreciate them all—the ones that have done well, and those that have done the best that they could.

Eva Louise Gallimore Boyd, age 101
Chickasha, Oklahoma

Born November 28, 1904 in Dublin, Georgia.
Photographed October 2, 2006 in Oklahoma City.
Denied access to segregated University of Oklahoma.
Earned bachelor's degree at Detroit Conservatory of Music.
Additional piano study at Northwestern University.

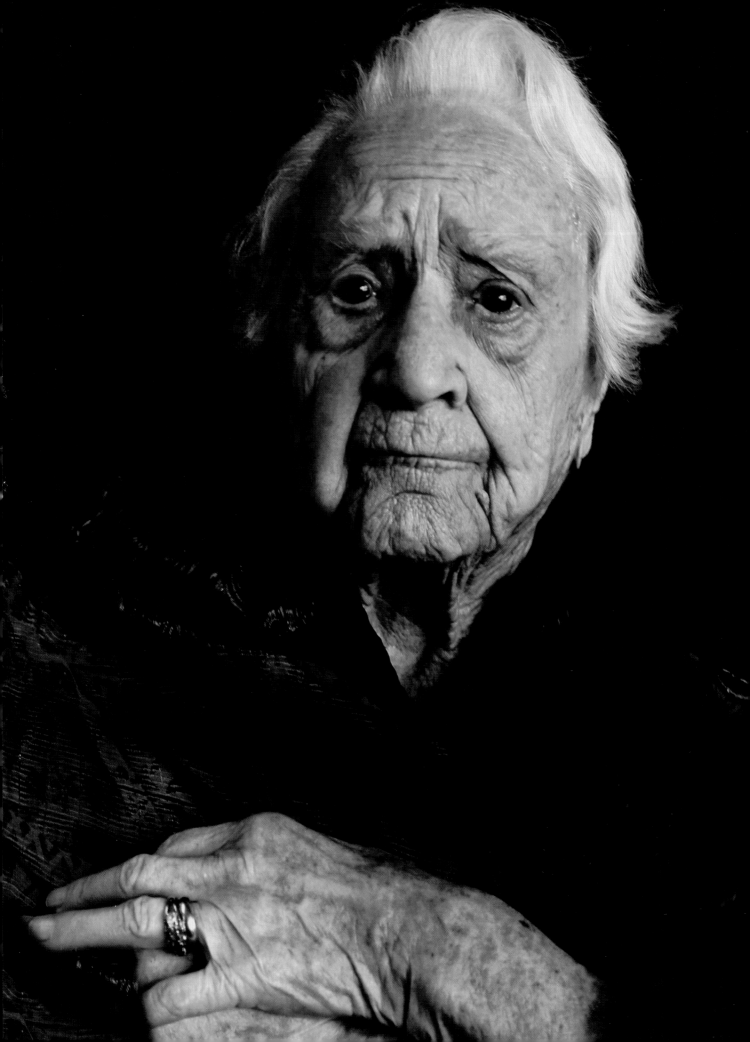

I always taught my children not to fight. They're all married now, and they don't fuss, don't fight.

I hear from all of them pretty near every day. We had nothing to worry about. Made life the best we could.

Julia Keddie Lydia Smalley Blevins, age 102
McAlester, Oklahoma

Born June 16, 1904 in Mellette, Creek Nation, I.T.
Photographed August 9, 2006 in McAlester.
Community midwife, nurse.
Owned one team of horses and one of mules; she plowed one field, husband the other.
Sister Sabie Hamilton also lived to 100; sister Elsie Ratliff died just before 100th birthday.

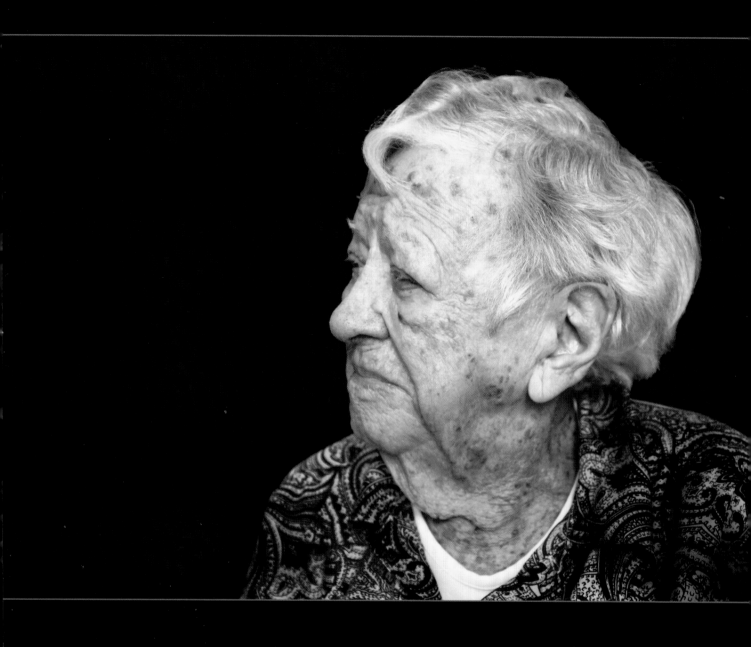

I taught school for 44 years, first and second grade. That was long ago. I tried to make it interesting for them. I taught at Lowell School, which was a poor section of town back then. School was more pleasant than home. They had a free lunch. And I loved them.

Dorothy Caloway Harris McGee Wolf Sullivan Ford, age 102
Tulsa, Oklahoma

Born February 2, 1904 in Tishomingo, Chickasaw Nation, I.T.
Photographed June 16, 2006 in Tulsa.
Traveled throughout Europe and Asia; favorite destination: Hong Kong.

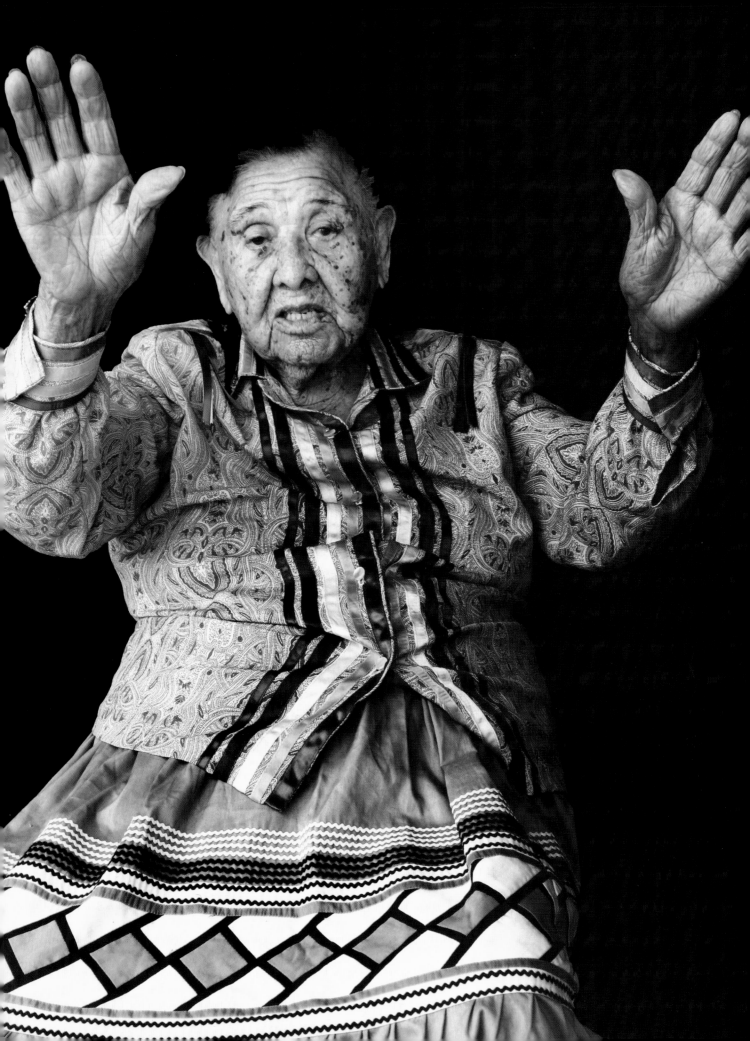

She taught by example. She'd walk all over town, to the various nursing homes. She'd fix the Indian ladies' favorite food, chicken and dumplings. She'd take their clothes home and mend them and wash them. She'd say 'why stand there watching? Treat them like you would treat your family.'

Ruby Mauk, on mother Martha May Berryhill

Martha May Berryhill, age 105
Okmulgee, Oklahoma

Born July 12, 1900 in Okmulgee County, Creek Nation, I.T.
Photographed June 16, 2006 at tribal celebration in Okmulgee.
Original Muscogee/Creek allottee.

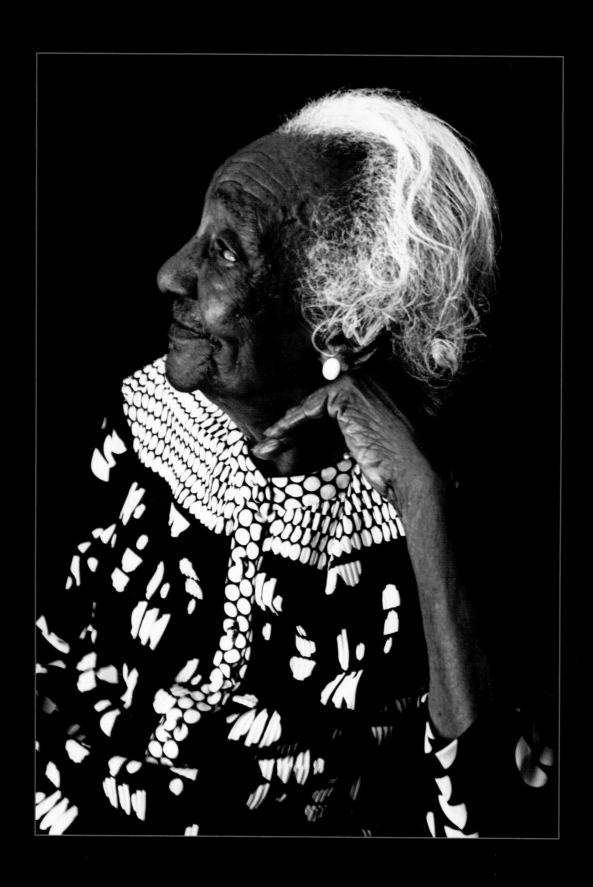

She never allowed us children to say 'I can't.'
She said 'I killed I can't, therefore you can. You can do it.
You can do anything.'

Loretta Blunt Jackson on mother Lillie Bell Curry Blunt

Lillie Bell Curry Blunt, age 99
Chickasha, Oklahoma

Born April 7, 1907 in Waco, Texas.
Photographed August 17, 2006 in Chickasha.
Great-grandfather, Charlie Jones, born in Cherokee Nation in 1834.
Life member, First Families of the Twin Territories.
Past Most Noble Governor for the Household of Ruth Number 50/50.
Mother of the Church: Church of the Living God, Pillar and Ground of the Truth.

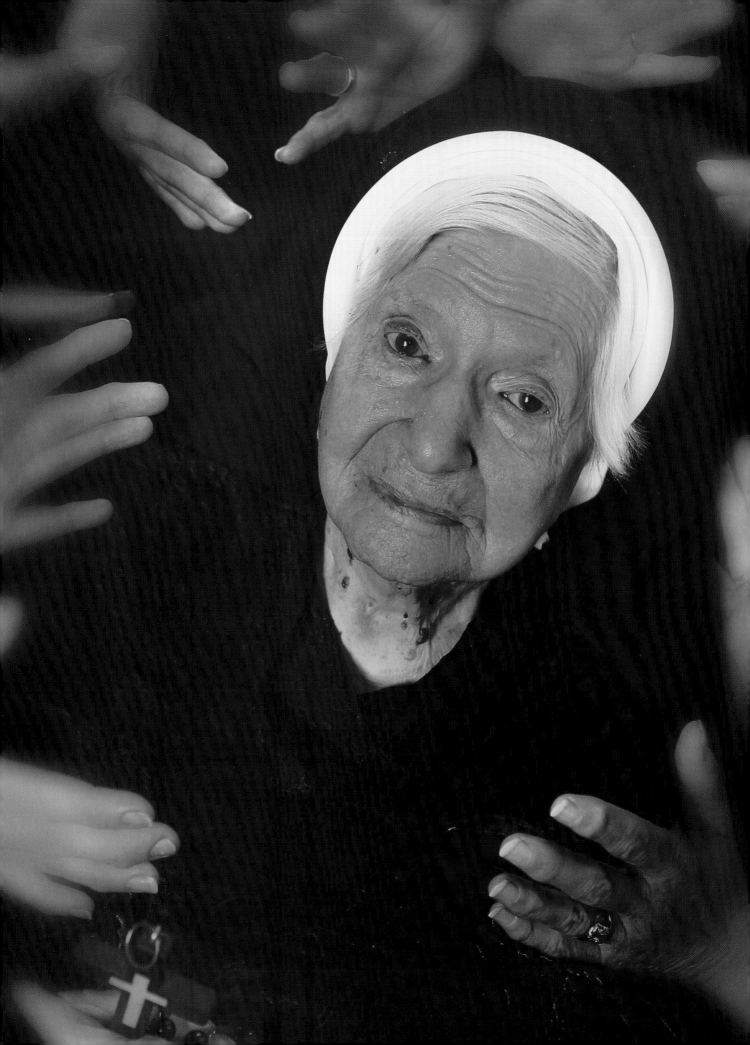

I taught elementary school for 70 years. That's a lifetime in itself. I taught a lot of lessons, alright. The most important? Always do your best. Just do your best. That's all you can do. And when you've done that, you've done everything. I taught them that.

Sister Mary Consolata Eckart, age 101
Edmond, Oklahoma

Born April 20, 1905 in Humboldt, Kansas.
Photographed June 28, 2006 in Edmond.
Order of Sisters of Mercy, ordained 1926.

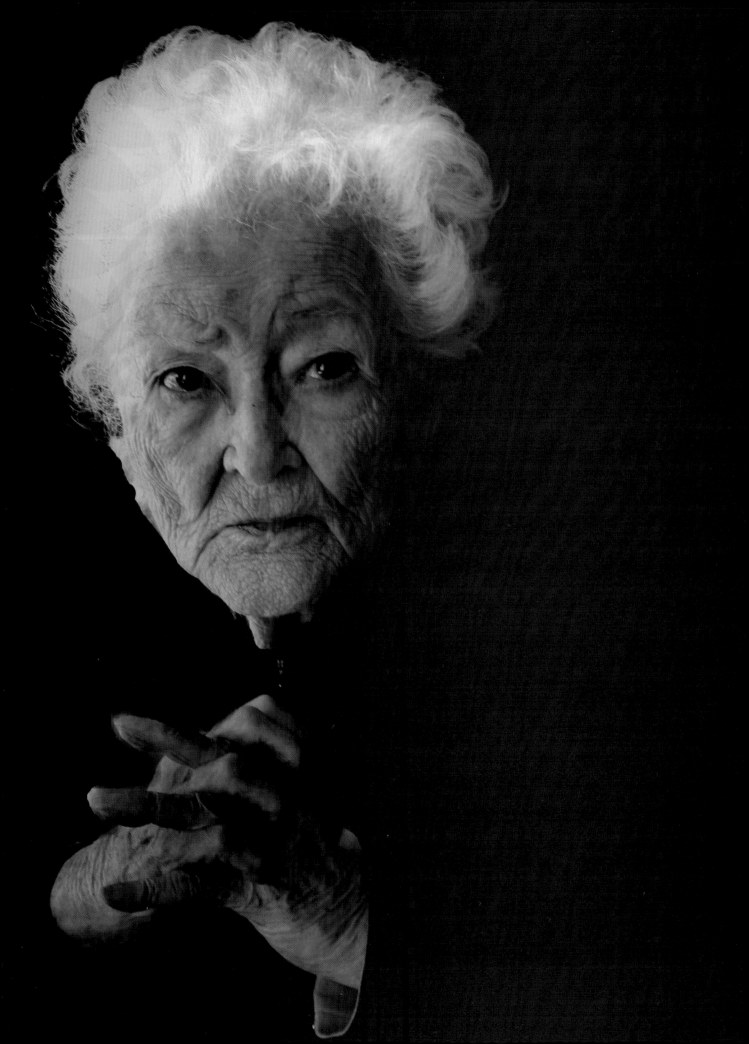

I learned to fly an airplane, just a single-engine Aeronica and Piper Cubs. Yes, it was rather unusual but I guess I was raised up to do unusual things. There were six girls in the family and one boy. My dad always said I was the best horseback rider in the county. 'Course, he had six daughters and he was proud of us all.

If you like to travel and move about, if you like people, you must have no prejudices. You can't teach people who are different and feel superior to them. I tried to show that whites and Indians could get along. To me, they were all just children. You can't tell by the looks of their skin what they're going to learn or what they're going to do. Some were more talented than others, but it wasn't by color. I treated everyone fairly.

Mildred Gertrude Fairchild Fisher, age 100
Chickasha, Oklahoma

Born April 14, 1906 in Mountain Park, O.T.
Photographed August 17, 2006 in Chickasha.
Taught for more than 40 years in Indian schools in Oklahoma, California, and Arizona.

147

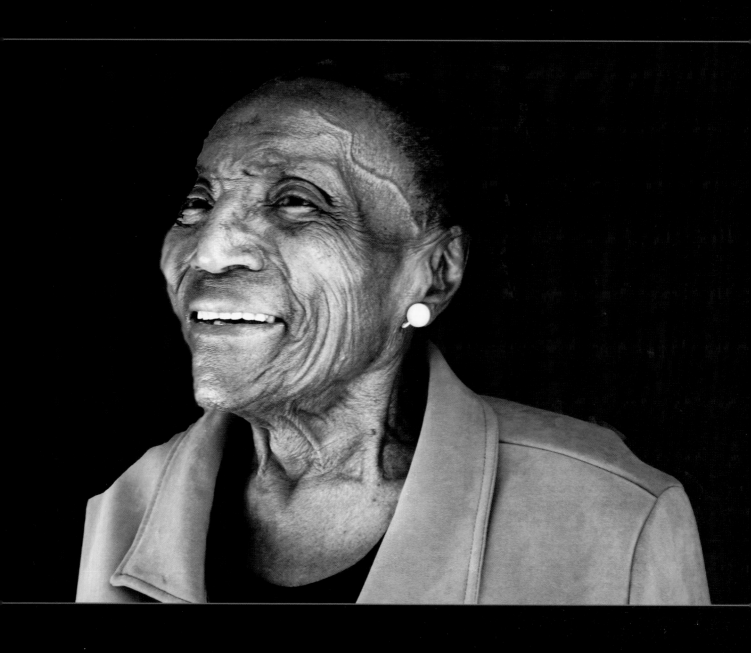

My mother let me stay in town with my older sister, so I never got to pick cotton or anything. I had never been no place but Arkansas before Oklahoma. I liked to see a place I'd never been.

Georgene Thomas Richardson, age 104
Oklahoma City, Oklahoma

Born February 2, 1902 in Pine Bluff, Arkansas.
Photographed October 2, 2006 in Oklahoma City.
Former teacher in one-room schoolhouse.

God put us all on this earth together. He made us different colors, but he wants us to live together.

LAVERNE COOKSEY DAVIS

Chapter VIII FAITH

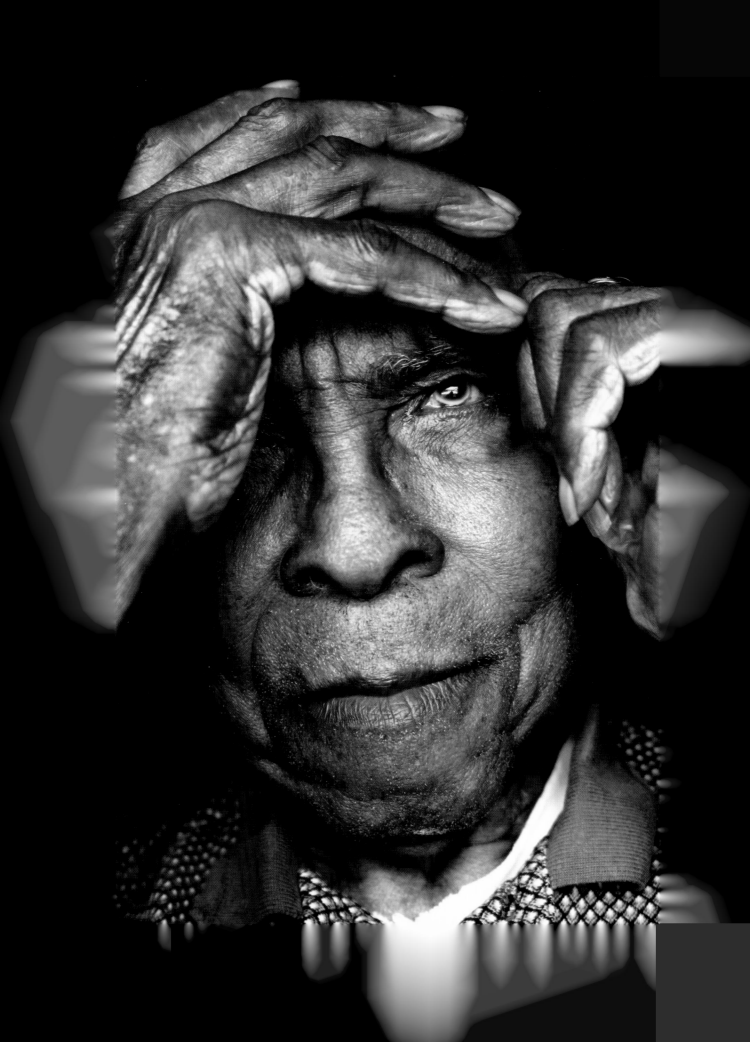

I was one of 17 children, and was never sick.
That's because of the fact I was raised on a farm.
What keeps me so healthy? The good Lord.

Thomas Jefferson Brown, age 101
Okmulgee, Oklahoma

Born March 1, 1905 in Wetumka, Creek Nation, I.T.
Photographed May 23, 2006 in Okmulgee.
Family received 160 acres from Bureau of Indian Affairs.
Family founded Brownsville settlement.

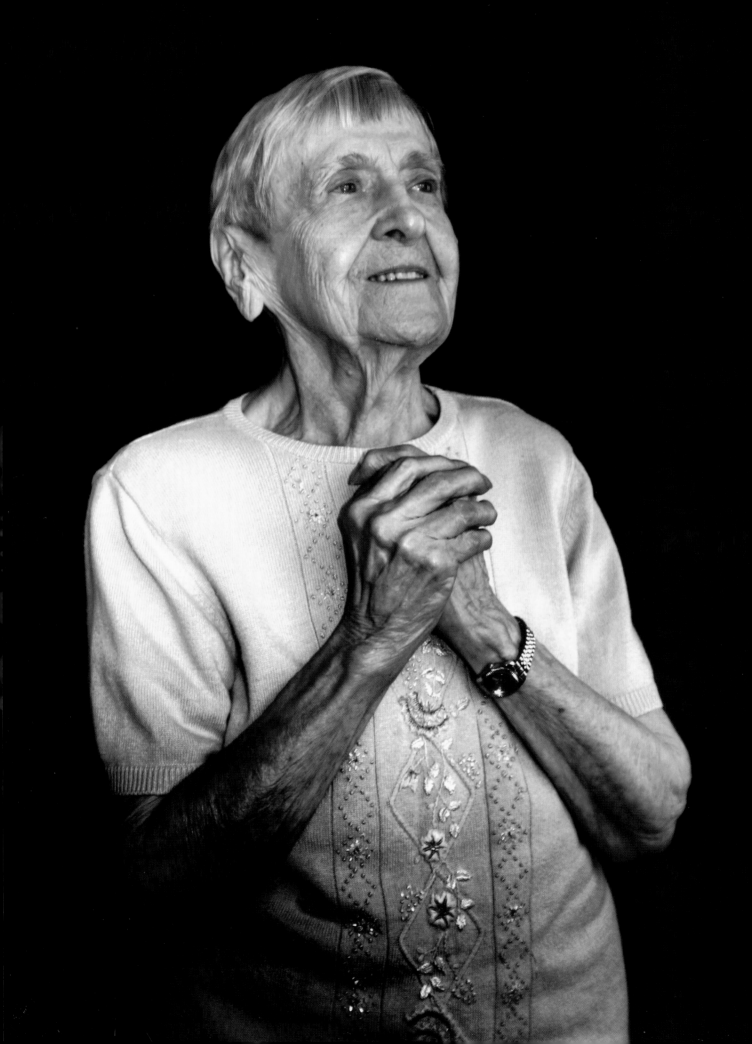

I'm ready when the Lord calls. He's going to take me home
right from my room.

Ethel Rose Zamba Brockelbank, age 99
Tulsa, Oklahoma

Born June 17, 1906 in Lyndora, Pennsylvania.
Photographed May 23, 2006 in Tulsa.
Stopped taking medicine at age 17.

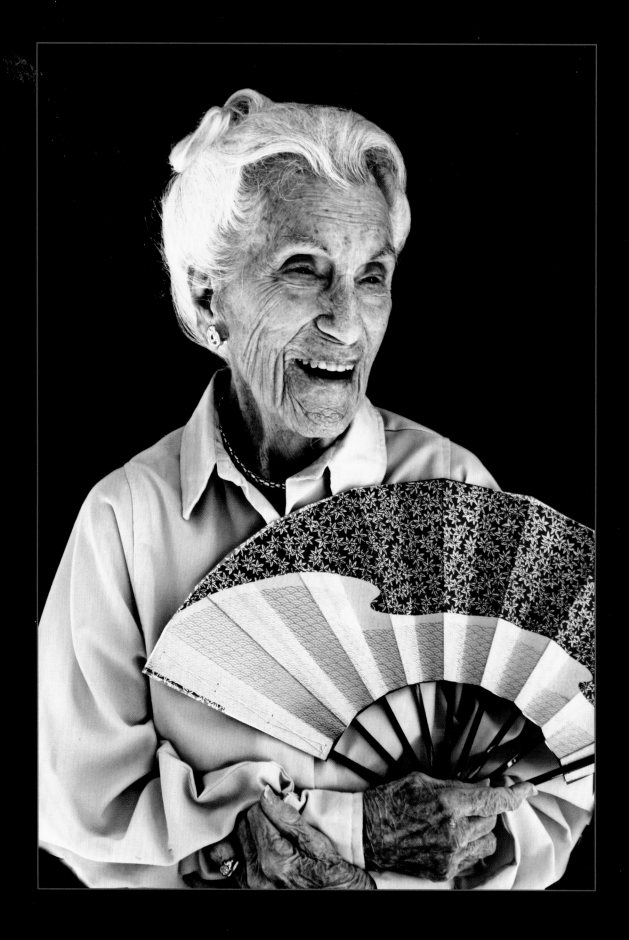

My main thought is do unto others the way you wish they'd do unto you. I use the Bible to help international students with English. One day I had 17—that was sort of an overflow. Several of them have gone home Christians.

Beulah-Mae Ellen Crowson Winter, age 102
Edmond, Oklahoma

Born June 15, 1904 in Denmark, Mississippi.
Photographed August 17, 2006 in Edmond.
Moved to Oklahoma at age 79.
Lives independently.

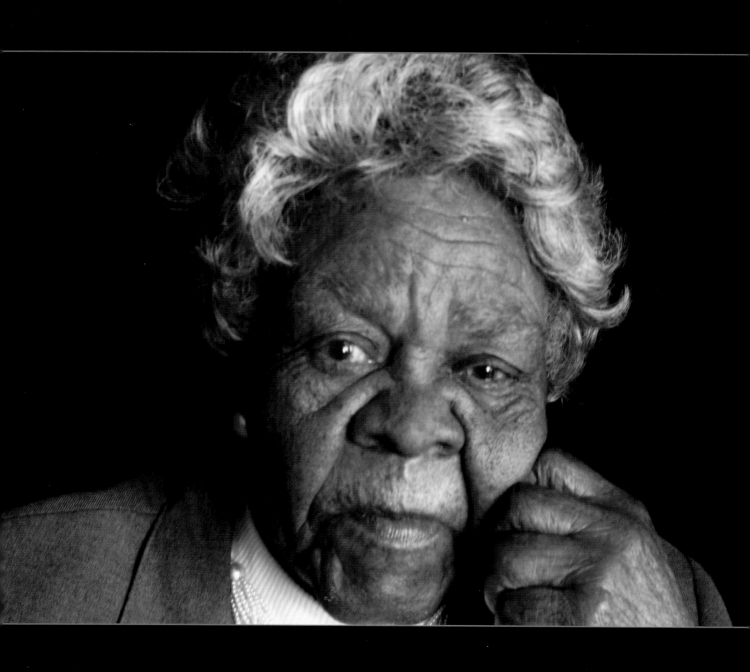

Try and love everyone, and trust in the Lord.

Lula Ball Jennings, age 102
Tulsa, Oklahoma

Born October 3, 1904 in Kosciusko, Mississippi.
Photographed November 16, 2006 at Oklahoma Centennial kickoff in Tulsa.
Retired farmer.
"Oldest Church Mother," Mohawk Baptist Church.

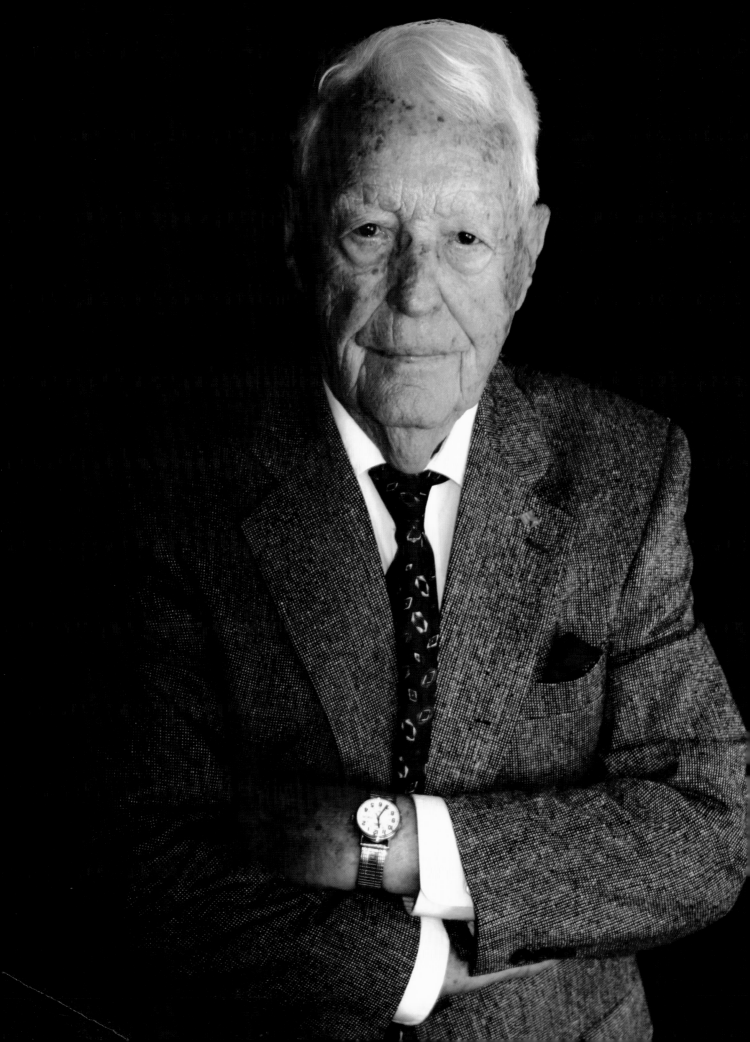

I was a builder. I've been retired 46 years. I know the Bible pretty well and try to live in accordance with the Bible. I live to be Christian. According to the Scriptures, I'm saved and I'm going to spend eternity with God, I think.

Forrest Edward Winston, age 98
Tulsa, Oklahoma

Born June 13, 1907 in Shawnee, O.T.
Photographed May 23, 2006 in Tulsa.
Four-decade resident of Oral Roberts' University Village.

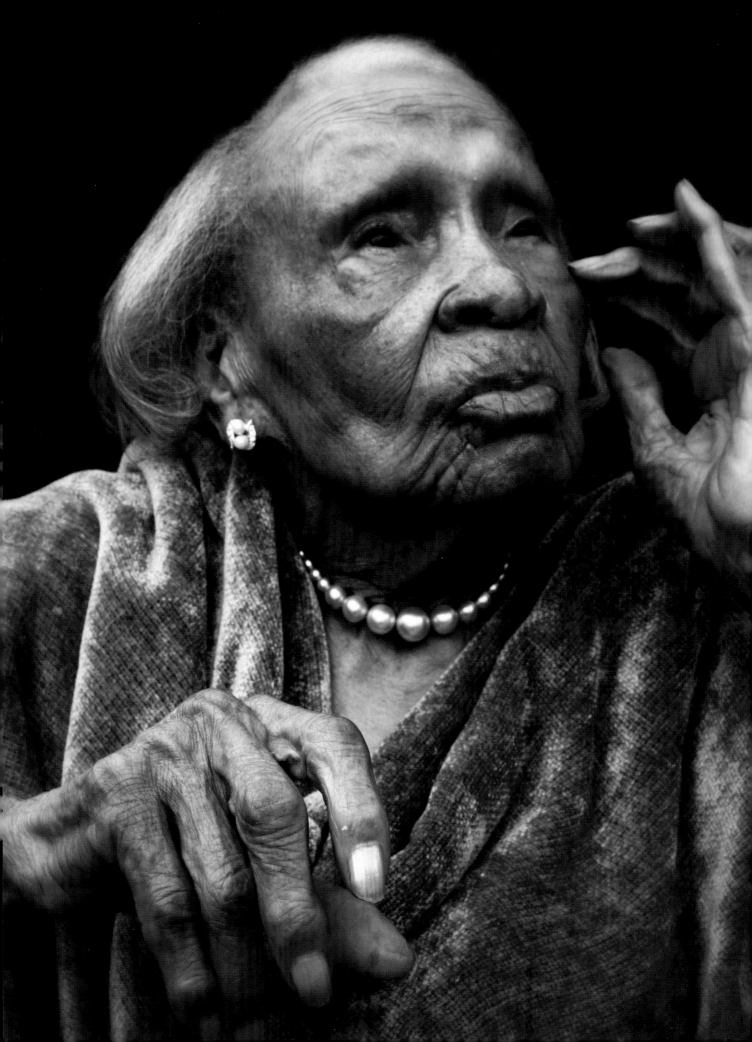

God put us all on this earth together. He made us different colors, but he wants us to live together.

LaVerne Cooksey Davis, age 102
Tulsa, Oklahoma

Born May 24, 1904 in Dallas, Texas.
Photographed June 19, 2006 in Tulsa.
Studied millinery design at Art Institute of Pittsburgh.
Survivor of the 1921 Tulsa Race Riot.

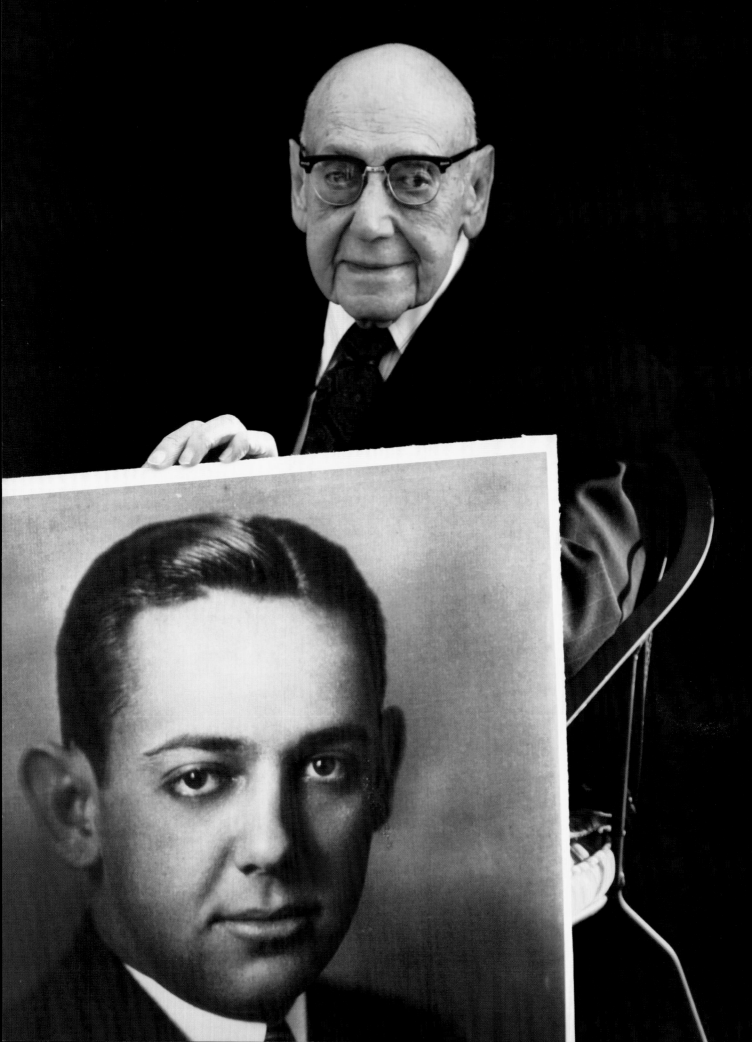

Social justice has been one of my main emphases in the ministry, which has not always been well received.

Rev. Philip Baier Wahl, age 100
Duncan, Oklahoma

Born August 17, 1906 in Oklahoma City, O.T.
Photographed August 19, 2006 in Duncan.
Pastor emeritus, First United Methodist Church, Duncan.
Inspired annual Phil Wahl Abolitionist Award, presented by Oklahoma Coalition to
 Abolish the Death Penalty.
Shown with photograph of himself as a young man, a surprise for his 100th birthday.

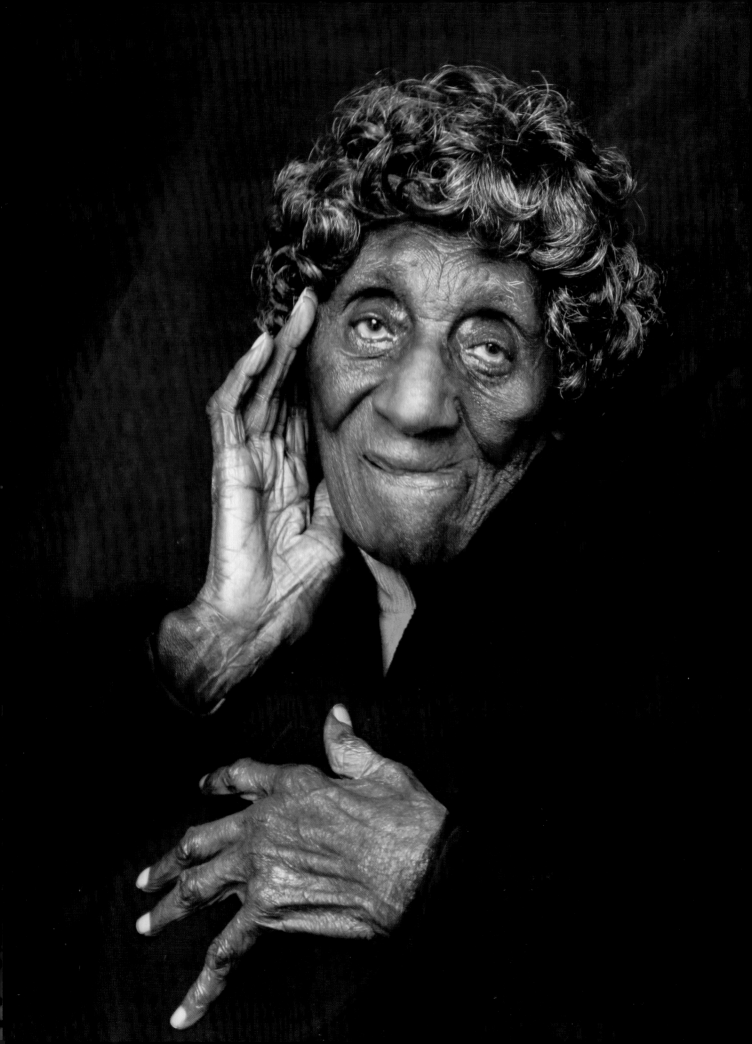

*Treat people right and the Lord will treat you right. If you misuse
people, the Lord will shorten your life.*

Jessie Mae Childs Carter, age 100
Tulsa, Oklahoma

Born August 14, 1906 in Lula, Chickasaw Nation, I.T.
Photographed November 16, 2006 at Oklahoma Centennial kickoff in Tulsa.
Shipbuilder during World War II.

I never smoked. I never
did get drunk. Never run
crazy with women.
I didn't have much fun, but
I lived a good long time!

ALLEN MARSHALL COX

Chapter IX VICES

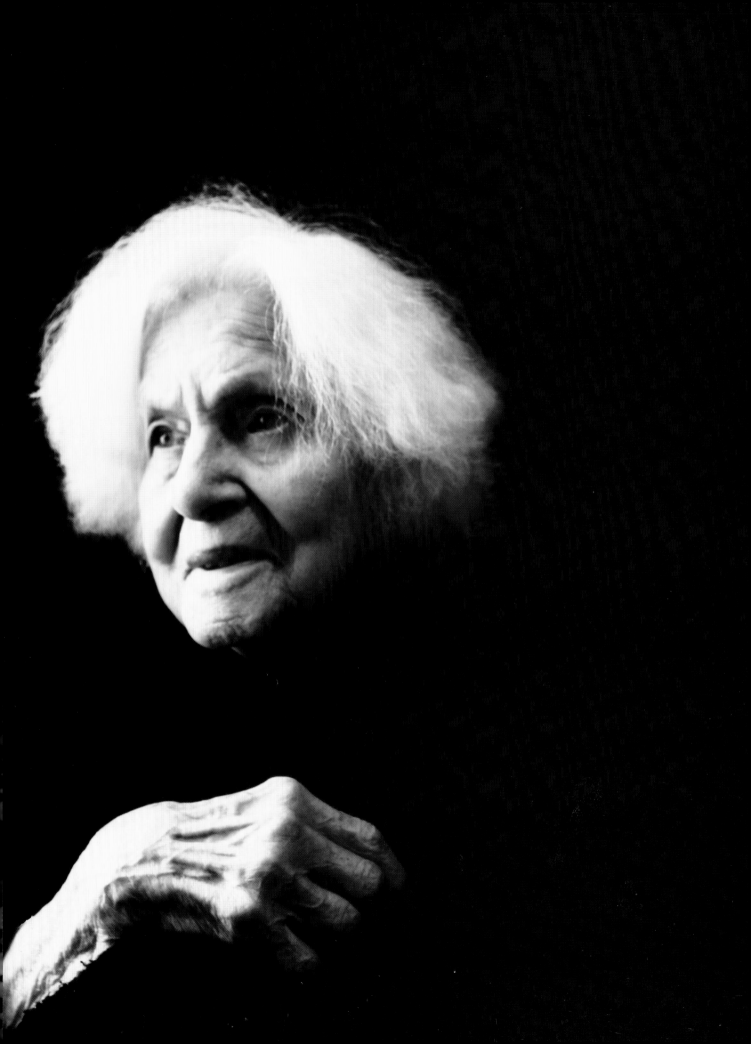

I live on dark chocolate. The darker the better.
I've eaten it all my life. Sometimes it's all I eat.

Margaret Dwelle Richmond, age 100
Tulsa, Oklahoma

Born November 11, 1905 in Cottonwood Falls, Kansas.
Photographed June 16, 2006 in Tulsa.
Earned bachelor's degree from Emporia State Teachers College.

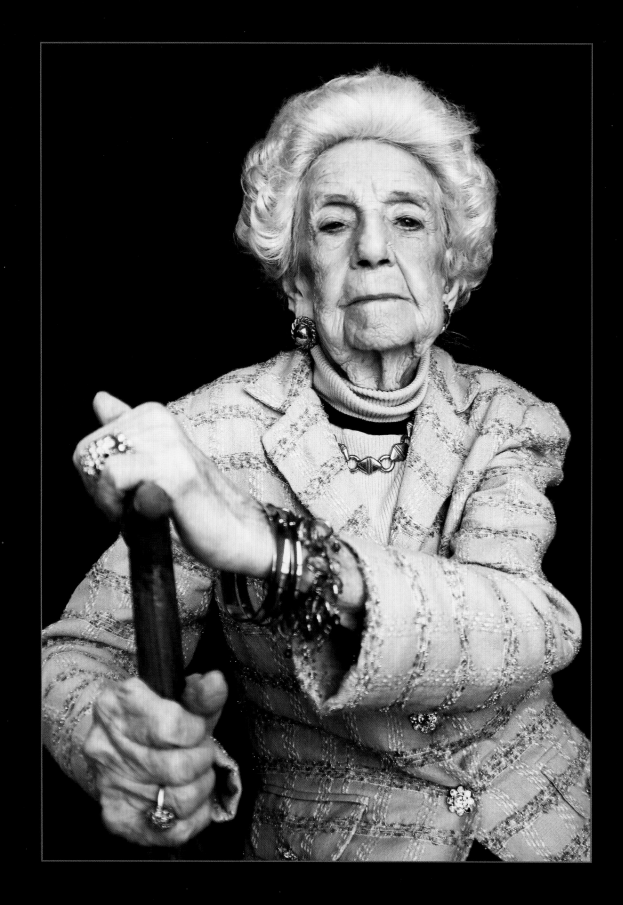

Drink a hot toddy every morning.

Phyllis Frances Long Benson Whitchurch, age 102
Tulsa, Oklahoma

Born May 11, 1904 in Greenfield, Missouri.
Photographed November 16, 2006 at Oklahoma Centennial kickoff in Tulsa.
Dental assistant for 23 years.
Traveled to California by Model-T.

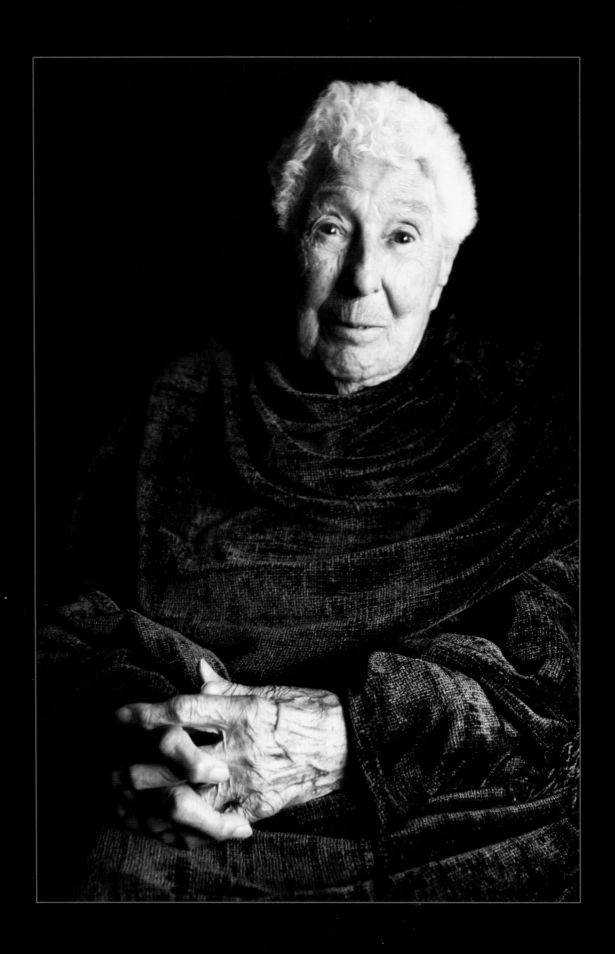

Eat dessert first.

Katherine Kubichek Timlin, age 104
Tulsa, Oklahoma

Born January 20, 1902 in O'Neill, Nebraska.
Photographed June 19, 2006 in Tulsa.
Moved to Oklahoma from Wyoming in 1980s.

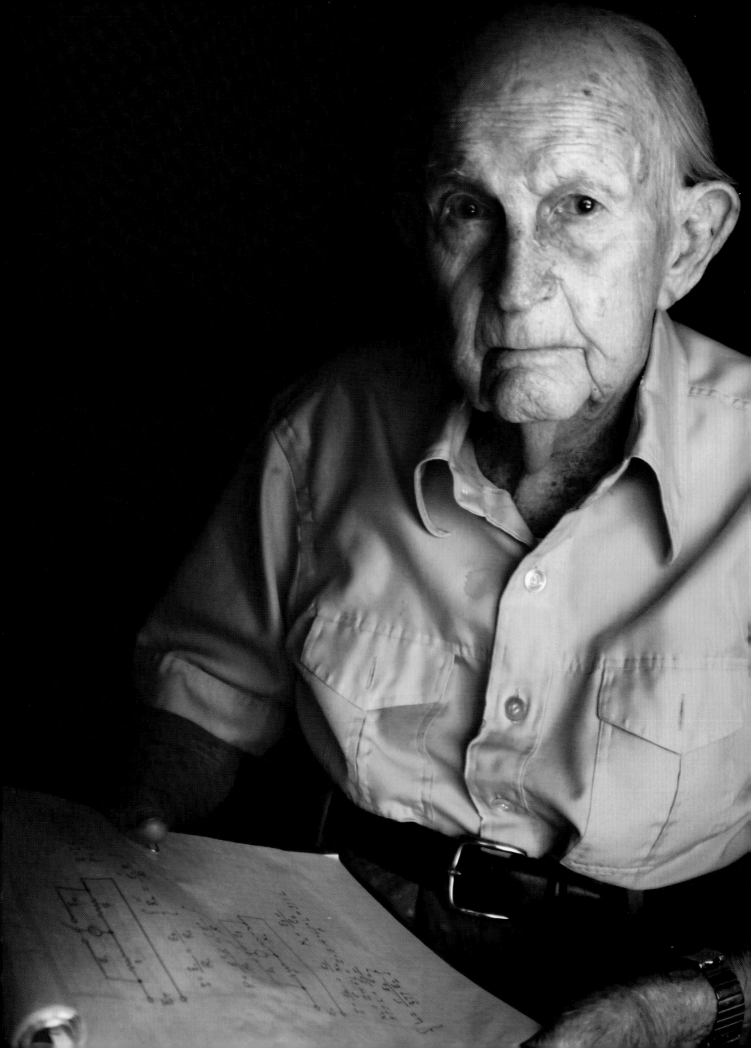

I smoked and drank and did everything. Did all the vices.
I'd probably do the same thing over.

Joseph Allen Niles, age 99
Tulsa, Oklahoma

Born December 24, 1906 in Guthrie, O.T.
Photographed May 23, 2006 in Tulsa.
Father, Alva Joseph Niles, carried statehood papers transferring Oklahoma from
 territories to a unified state.
Maternal grandfather, J.W. McNeal, made the 1889 Land Run and established
 state's first bank.
Paternal grandfather, Albert G. Niles, fought as Union soldier at 14, survived Andersonville
 Confederate prisoner of war camp and the boiler explosion of the Mississippi steamboat
 Sultana—the deadliest U.S. maritime disaster, which killed 1,600.

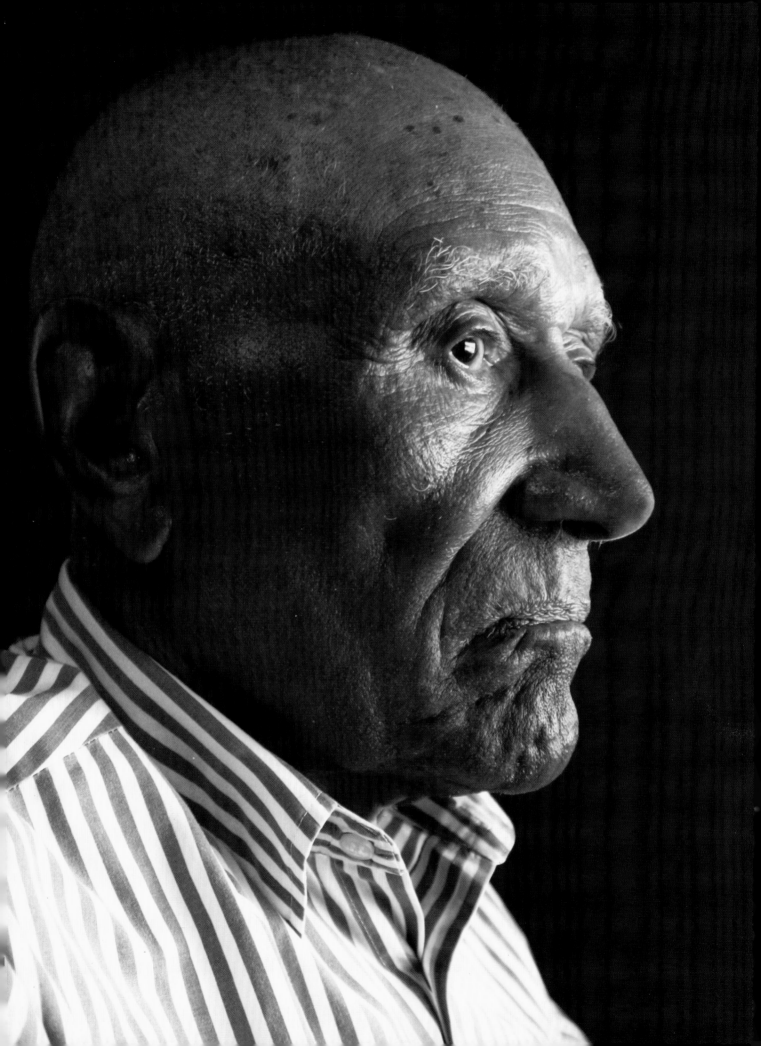

I eat everything that comes along. I eat when I get hungry,
don't eat if I'm not hungry, morning and night.

Jeremiah Fields, age 101
Okmulgee, Oklahoma

Born June 22, 1904 in Wewoka, Creek Nation, I.T.
Photographed May 23, 2006 in Okmulgee.
One of 16 children.
One of first two African-Americans to join Oklahoma Cattlemen's Association.
Deacon and trustee of St. Matthew's Baptist Church.

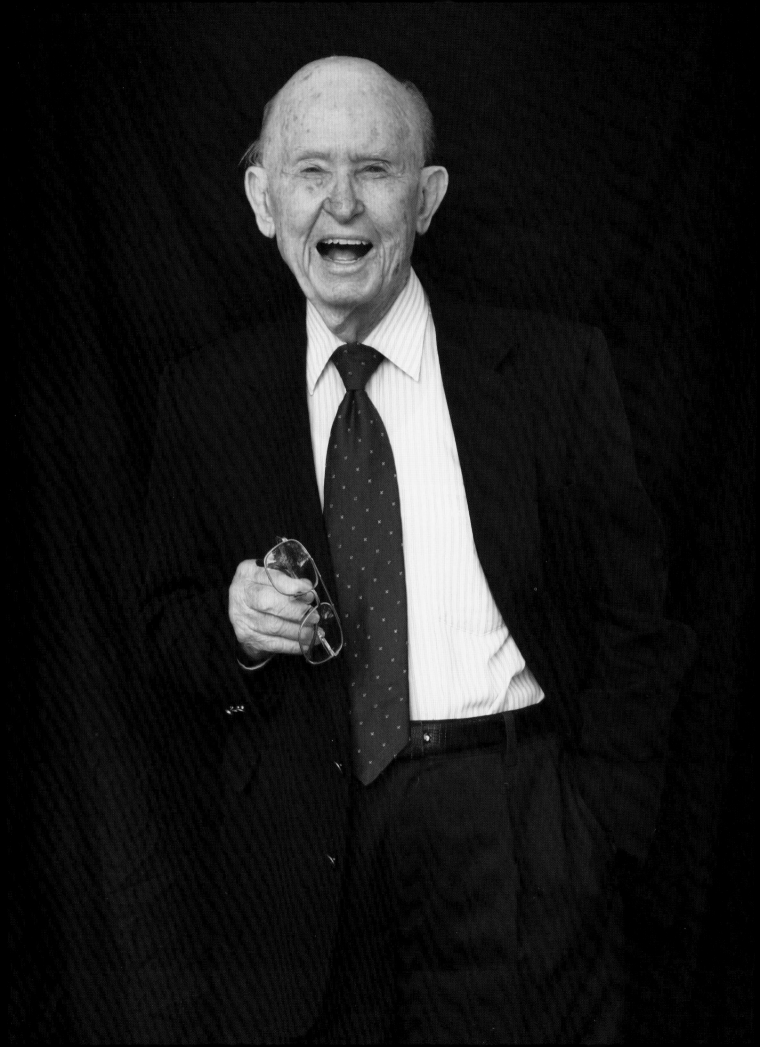

I told the doctor I never smoked. I never did get drunk.
Never run crazy with women. I didn't have much fun,
but I lived a good long time.

Allen Marshall Cox, age 100
Tulsa, Oklahoma

Born December 14, 1905 in Whitefield, I.T.
Photographed June 19, 2006 in Tulsa.
Long-time junior high principal.

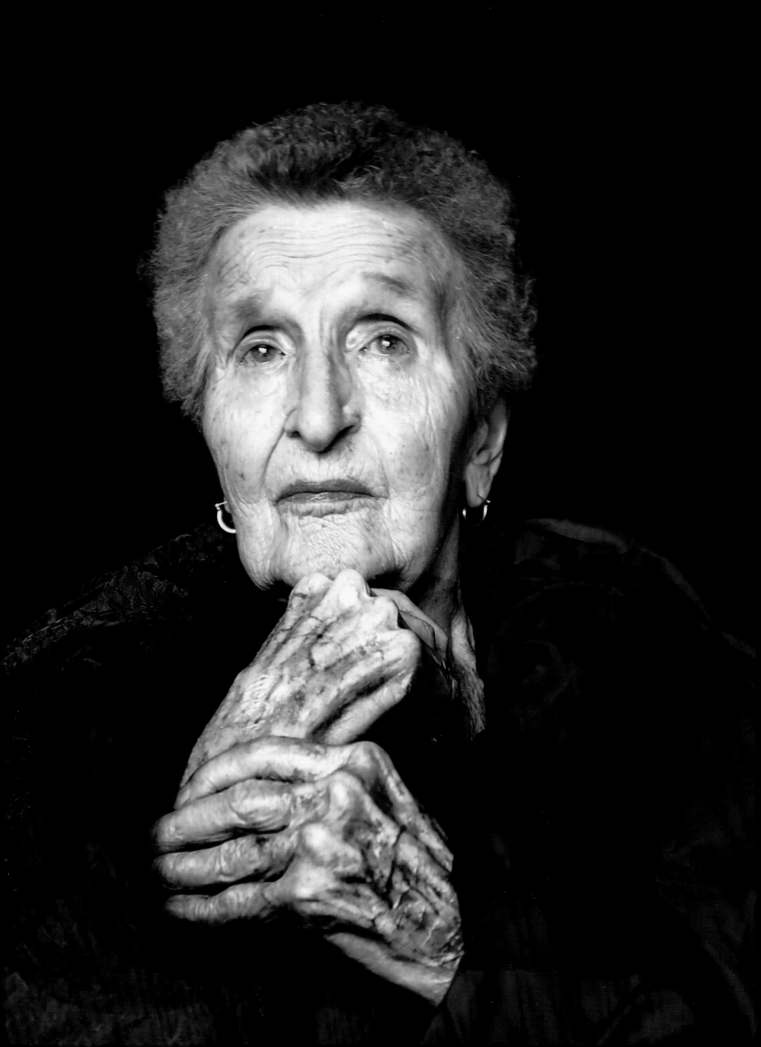

I could make five or six pies at a time, cobblers and pies.
I made chocolate, cherry cream, pecan, coconut, lemon.
My favorite, though, is peanut butter pie.

Dovie Gladys Harper Treadwell, age 100
Marietta, Oklahoma

Born November 16, 1906 in Love County, Chicaksaw Nation, I.T.
Photographed February 8, 2007 in Marietta.
Known countywide for her baking skills at the old Hub Restaurant.

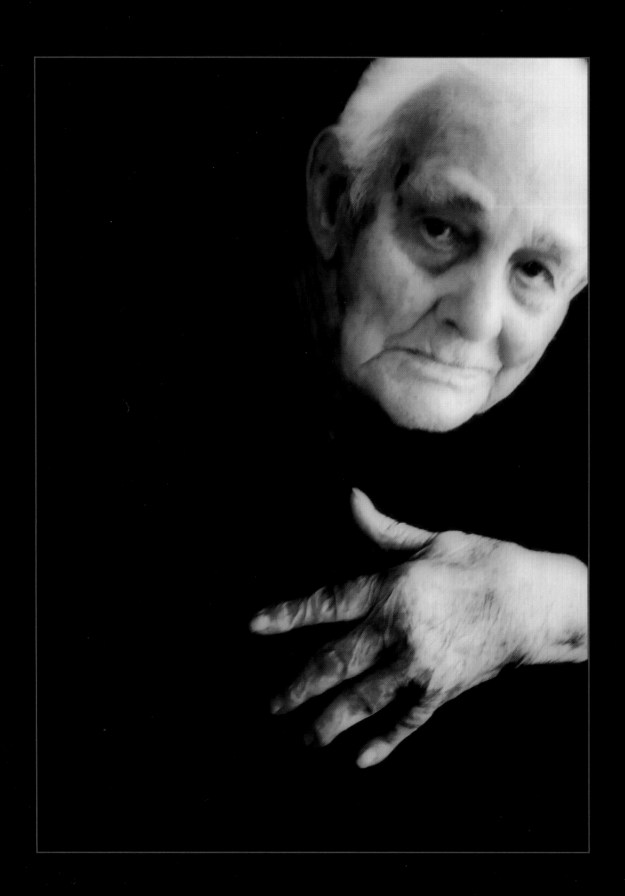

I went barefoot all my life, even when I worked in the fields.
Later on, they wouldn't hire me because I wouldn't wear shoes,
so I'd put them on 'til they weren't watching, then take them off.

I haven't had a shoe on in two years. I only wear socks.

John Oscar Akers, age 103
Dougherty, Oklahoma

Born January 17, 1904 in Dougherty, Chickasaw Nation, I.T.
Photographed February 8, 2007 in Davis.
Worked 22 years for asphalt company.

Things are better now than they were. But we never noticed the bad back then. That was just life.

RUBY LOIS OWENS SANDERS

Chapter X **THEN AND NOW**

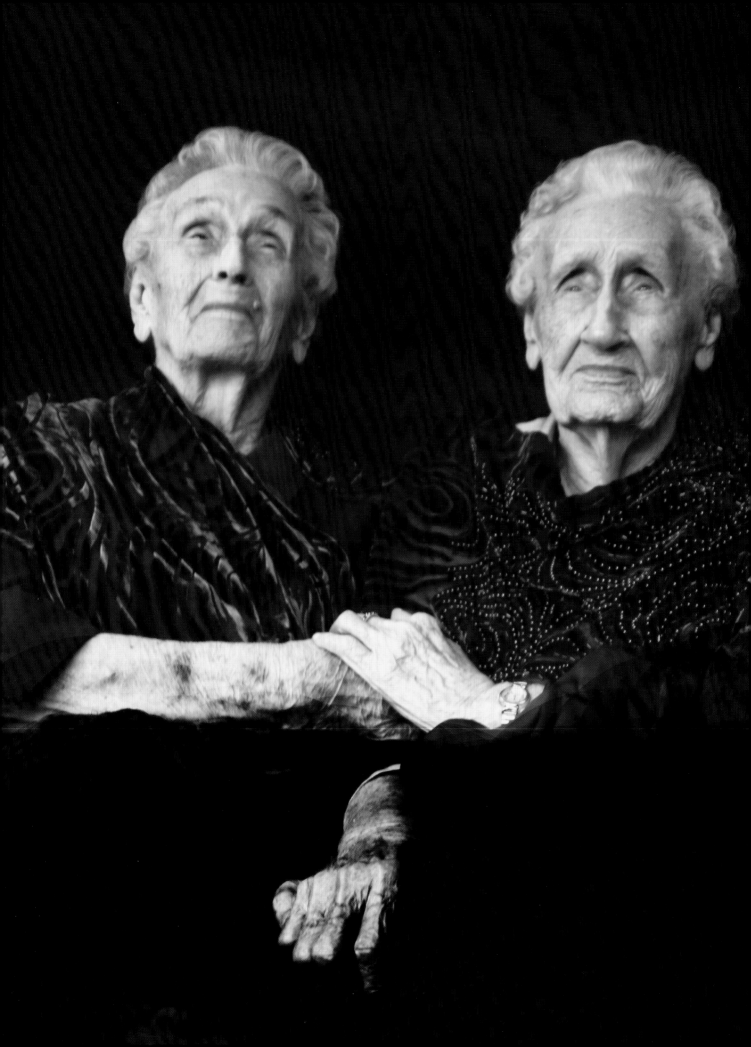

OWENS SISTERS

Things are better now than they were. But we never noticed the bad back then. That was just life.

Ruby Lois Owens Sanders, age 101, left
Madill, Oklahoma

Born January 23, 1906 in Marshall County, Chickasaw Nation, I.T.
Photographed February 8, 2007 in Madill.
Mother of nine.
With Mildred, Oklahoma's oldest set of sisters.

I just know that when you're a farmer, you have a dry year and that's it. You make do.
Back then we had to make do a lot of times.

Mildred Maggie Owens Devins Davis, age 103, right
Madill, Oklahoma

Born September 23, 1903 in Marshall County, Chickasaw Nation, I.T.
Photographed February 8, 2007 in Madill.
Survived cancer at 80, hip surgery at 99.

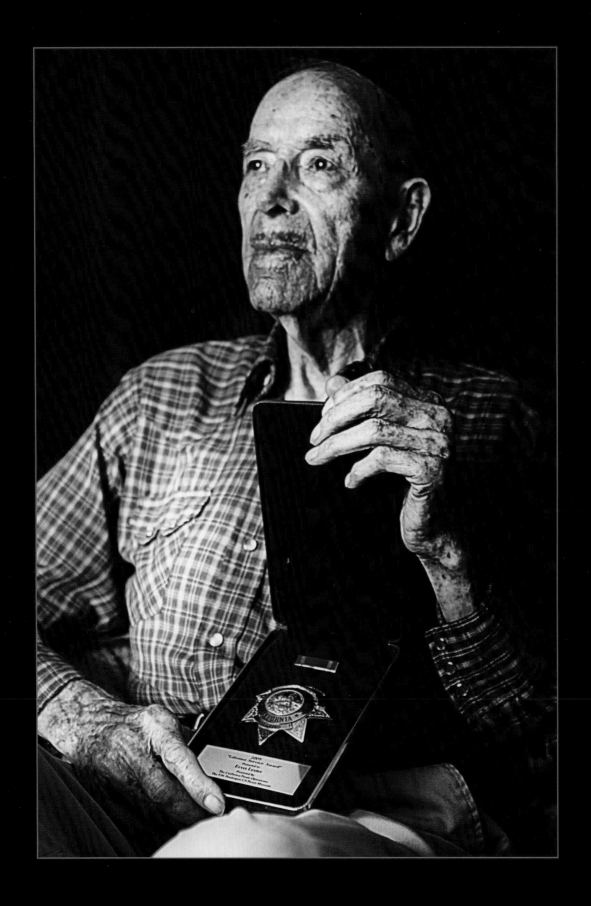

I started out being a very liberal guy. I voted for Franklin Delano Roosevelt four times. Through the '60s, I got a little more conservative. I'm just a little bit right of John Birch now.

Ervis Walter Lester, age 104
Rush Springs, Oklahoma

Born November 12, 1901, in Stamford, Texas.
Photographed June 24, 2006 in Rush Springs.
Former deputy police commissioner in Los Angeles, California.

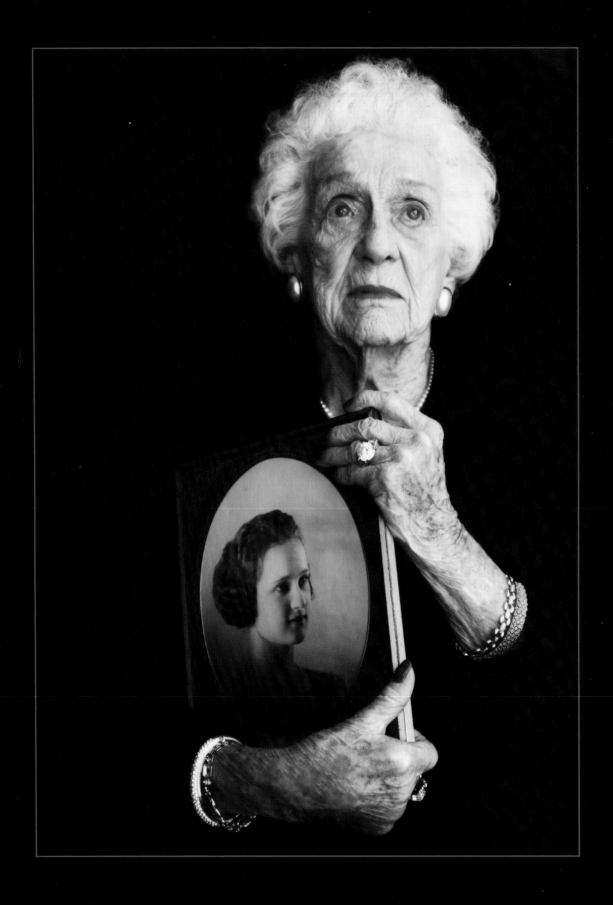

During the Depression, the banker told her family that they were better off than he was. They had food.

They used a horse and plow until 1950, when they finally got a pickup and a tractor. They were just hard workers. They didn't drink, didn't smoke, and managed their money well. Even now, she hardly sits down. She wants to work.

Mary Jane Fielden on mother Mary Bethana Whelchel Cabe

Mary Bethana Whelchel Cabe, age 103
Westville, Oklahoma

Born December 14, 1903 in Westville, I.T.
Photographed February 17, 2007 in Edmond.
Mother had 14 children, eight survived childhood.
Original Cherokee allottee.
Ancestors came to Oklahoma on Trail of Tears.
Retired farmer.
Worked in strawberry plant and soup factory to put daughter through college.

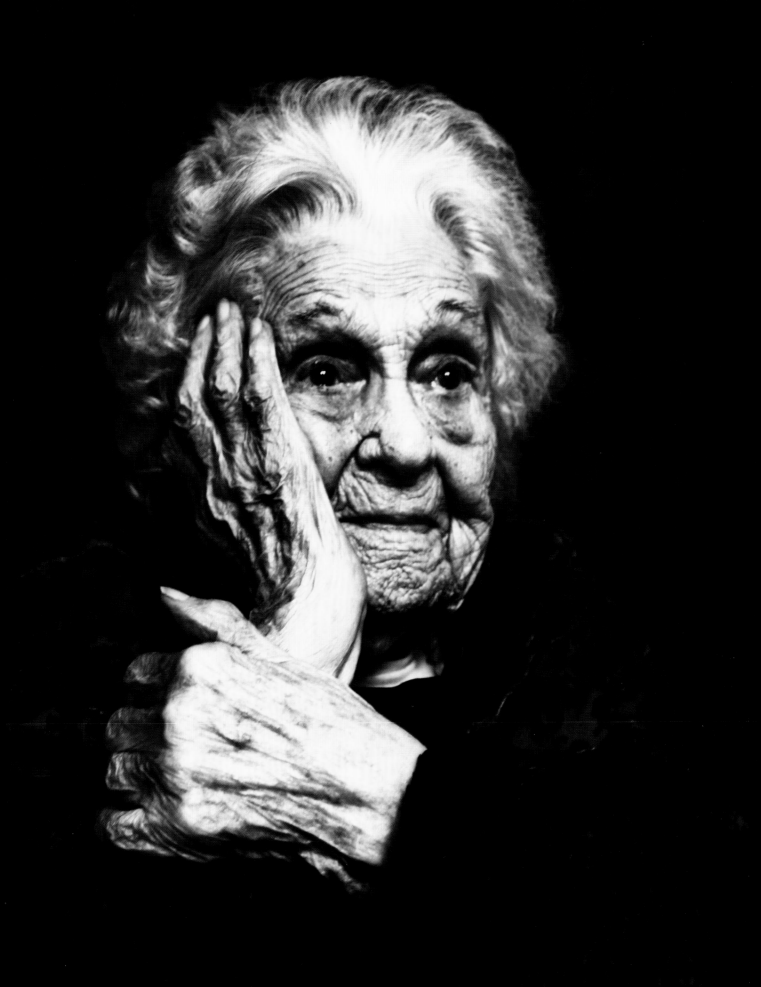

My grandmother was Cherokee, Cherokee and Choctaw. She had 11 kids. When we were sick, she'd go down to the river with a bucket and a spade and dig up some roots. That was our medicine.

Now I take 10 pills a night.

Dora Devie Matthews Chapman, age 104
Tulsa, Oklahoma

Born November 30, 1901 in Merrit, Texas.
Photographed June 19, 2006 in Tulsa.
Came to Oklahoma by covered wagon in 1908.
Settled in Duncan, and later lived in Geronimo, Healdton, and Tulsa.
Schooling ended after sixth grade.

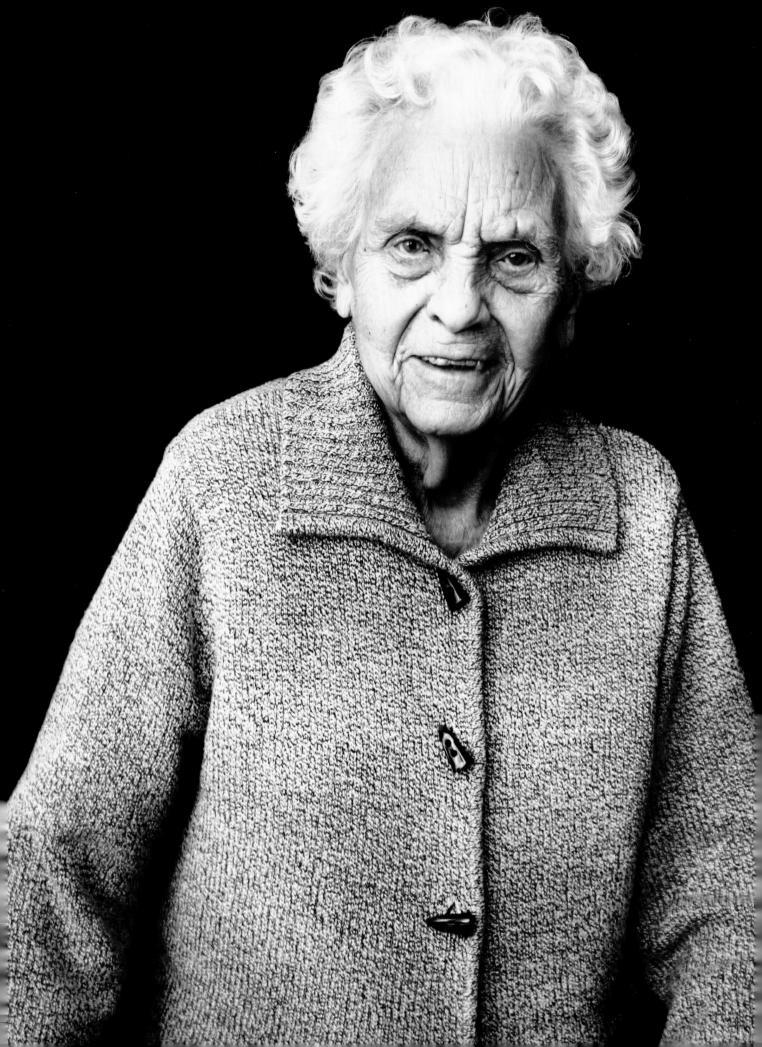

I would say to people they should go out and have a good time, like we did. But I don't think they do.

It's just different. Kids are just different. We didn't have television. They do.

Frieda Wilamena Meier Wiersig, age 103
Alva, Oklahoma

Born October 29, 1902 in Lincoln, Kansas.
Photographed August 11, 2006 in Alva.
Enjoys singing Lutheran hymns in native German language.

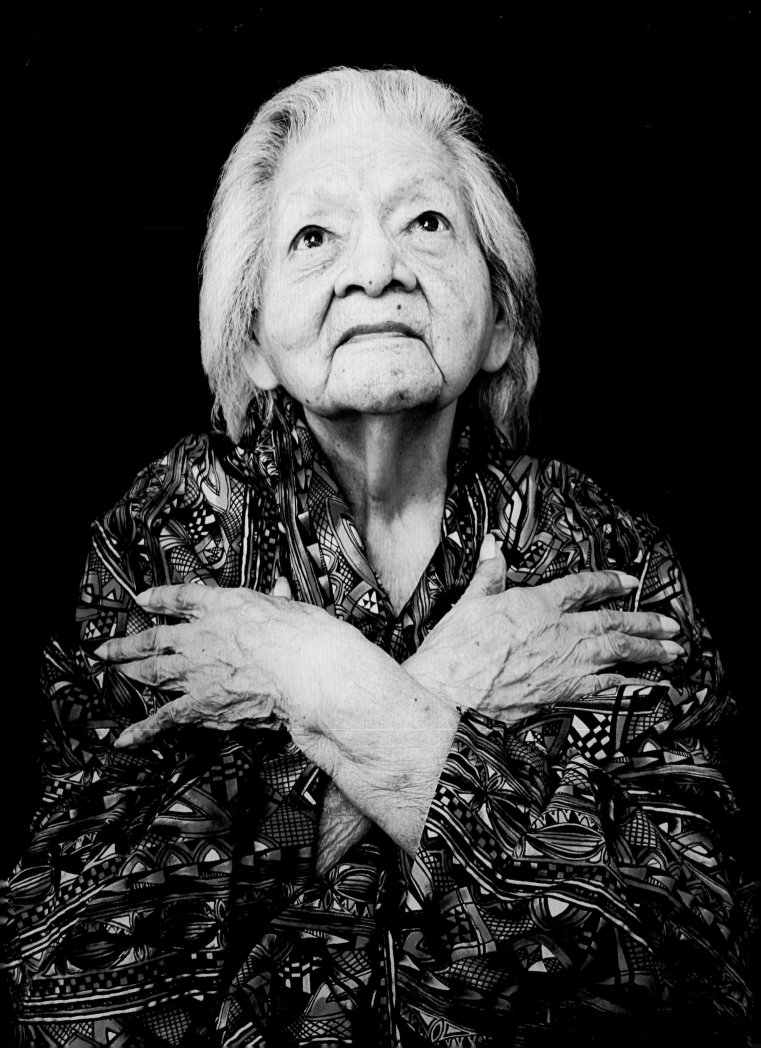

We didn't have a whole lot, but we didn't really want for anything either.

Ida Turner Lewis, age 100
Oklahoma City, Oklahoma

Born July 14, 1906 in Glover, Choctaw Nation, I.T.
Photographed August 18, 2006 in Oklahoma City.
Full-blood Choctaw.
Attended Wheelock Academy for Girls.
Twenty-five-year breast cancer survivor.
Received more than 500 roses on 100th birthday.
Eldest brother, James Edwards, was one of original World War I code talkers.

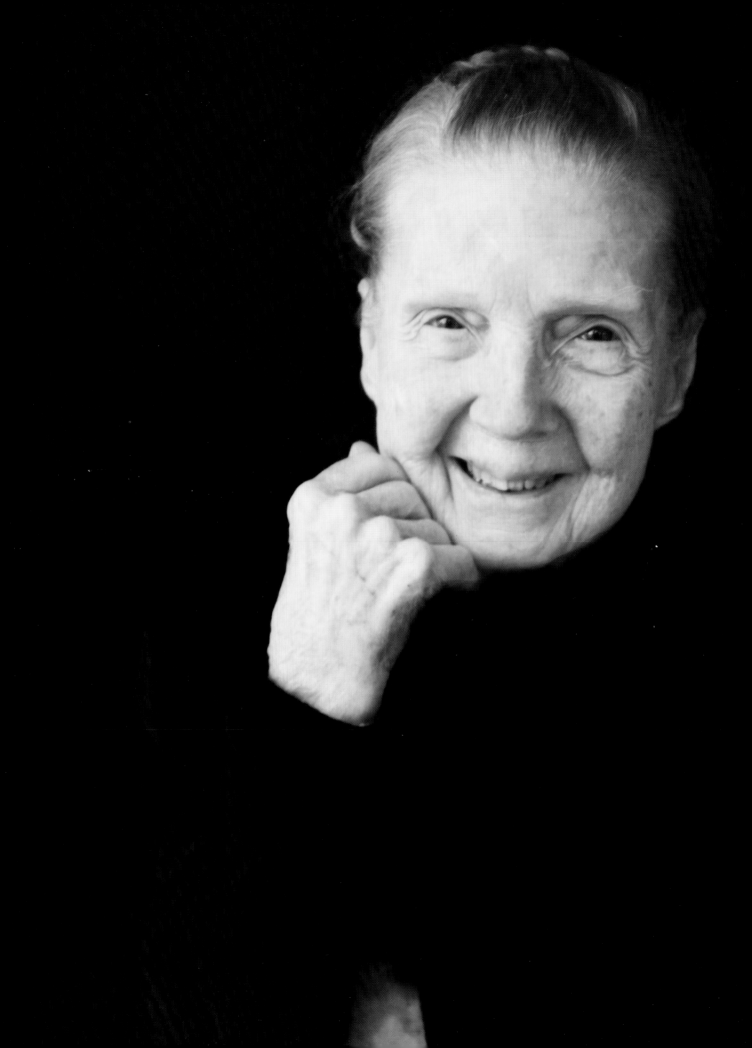

Some things are easier now. But to me, life was simpler years back. People weren't in such a hurry all the time.

Vivian Edna Drum Burch, age 100
Ardmore, Oklahoma

Born August 7, 1906 in Waverly, Kansas.
Photographed February 8, 2007 in Ardmore.
Moved to Oklahoma in 1933 for job as medical technologist.

If I'd known I was going to live this long, I would have fixed up my house.

IMA CARE MALONEY WILSON

Chapter XI PARTING SHOTS

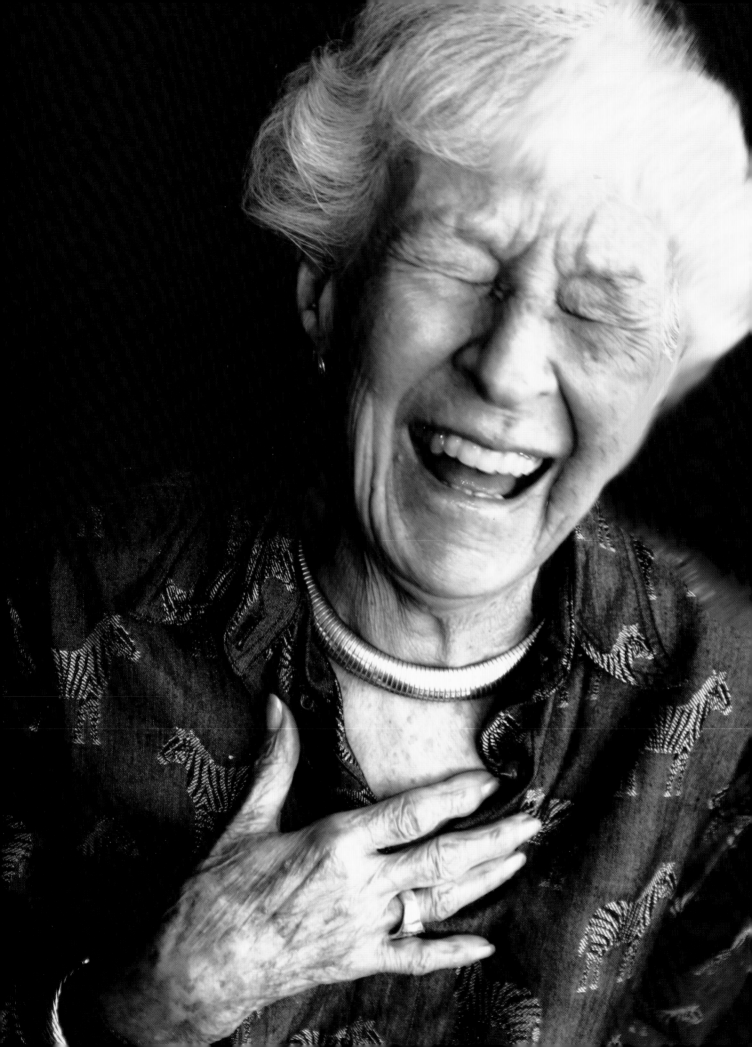

I have so many good-looking dresses, but I can't wear them.
It's just hell to put on pantyhose.

Greta Cottrell Woodson Storey Saye Mill Heslet, age 100
Tulsa, Oklahoma

Born December 16, 1905 in Newkirk, O.T.
Photographed May 12, 2006 in Tulsa.
Former singer, known as "The Whispering Contralto."
Taught all eight grades in one-room schoolhouse in Dilworth Oilfield, Kay County.
Divorced once.
Widowed four times.

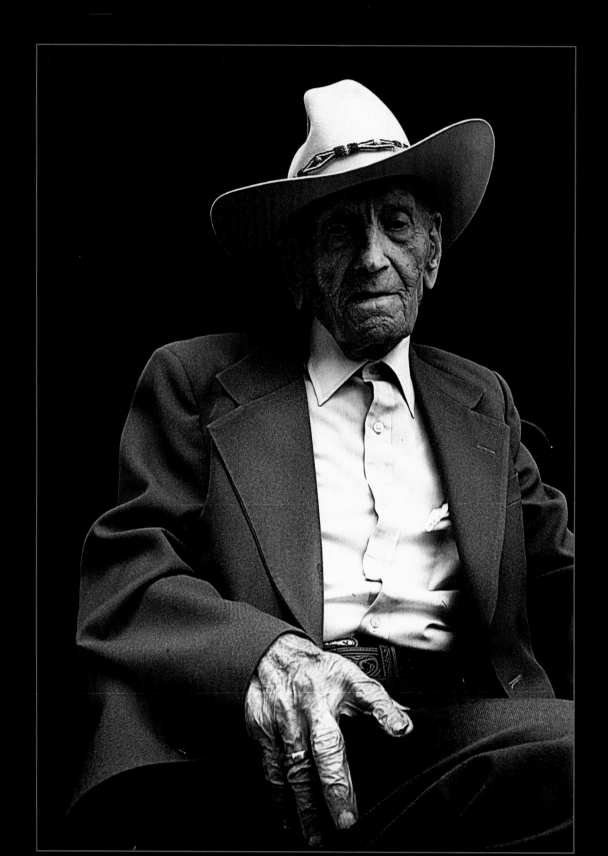

I enjoy life. I love kids.
If I ever get married again, I'm going to have a whole houseful.

Roy Elmore Giles, age 103
Tulsa, Oklahoma

Born August 17, 1902 in Pryor, Cherokee Nation, I.T.
Photographed May 1, 2006 in Tulsa.
Former Texas League Ballpark groundskeeper.
Retired master upholsterer for American Airlines.

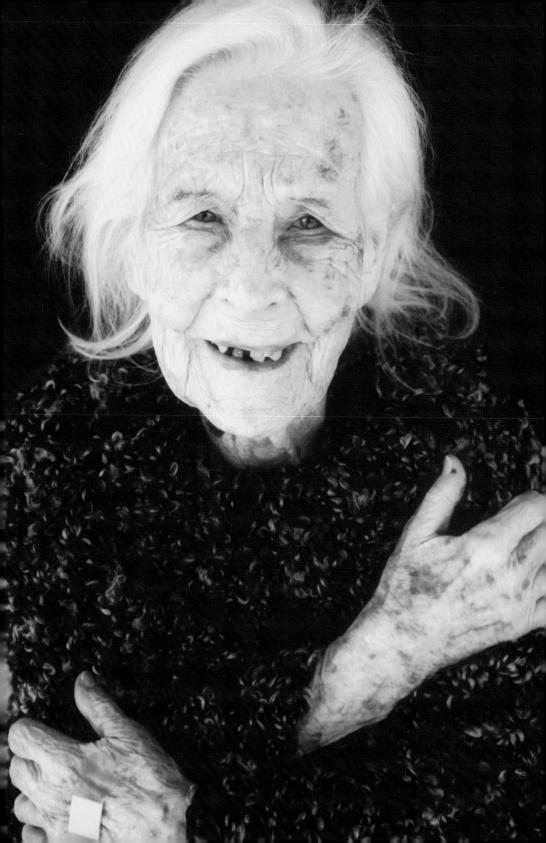

If I'd known I was going to live this long,
I would have fixed up my house.

Ima Care Maloney Wilson, age 101
Hennessey, Oklahoma

Born February 3, 1906 in Goltry, O.T.
Photographed February 17, 2007 in Hennessey.
Father staked quarter-section in 1889 run.
One of eight children.
Named after older sister, Iva Clare.
Voracious reader of paperbacks; needs no reading glasses.

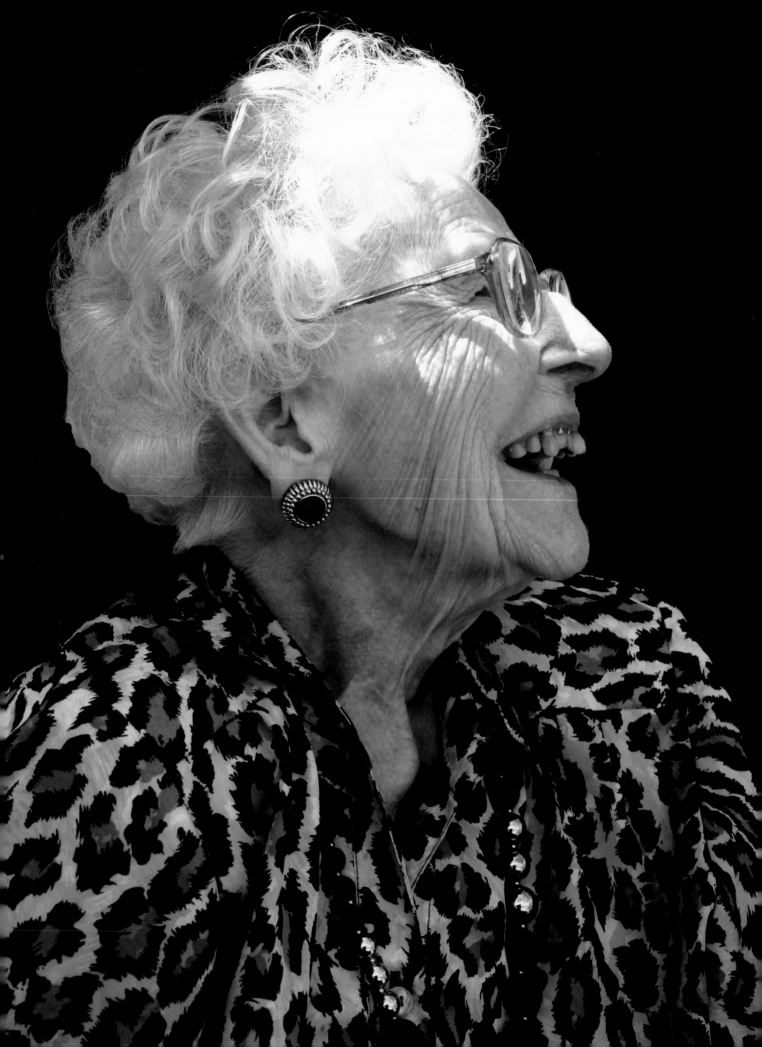

If I've learned anything, I've forgotten it all!

Ruth Lowry Winters, age 98
Edmond, Oklahoma

Born December 27, 1907 in Weatherford, Oklahoma.
Photographed May 3, 2006 in Edmond.
Father homesteaded in O.T. in 1894.

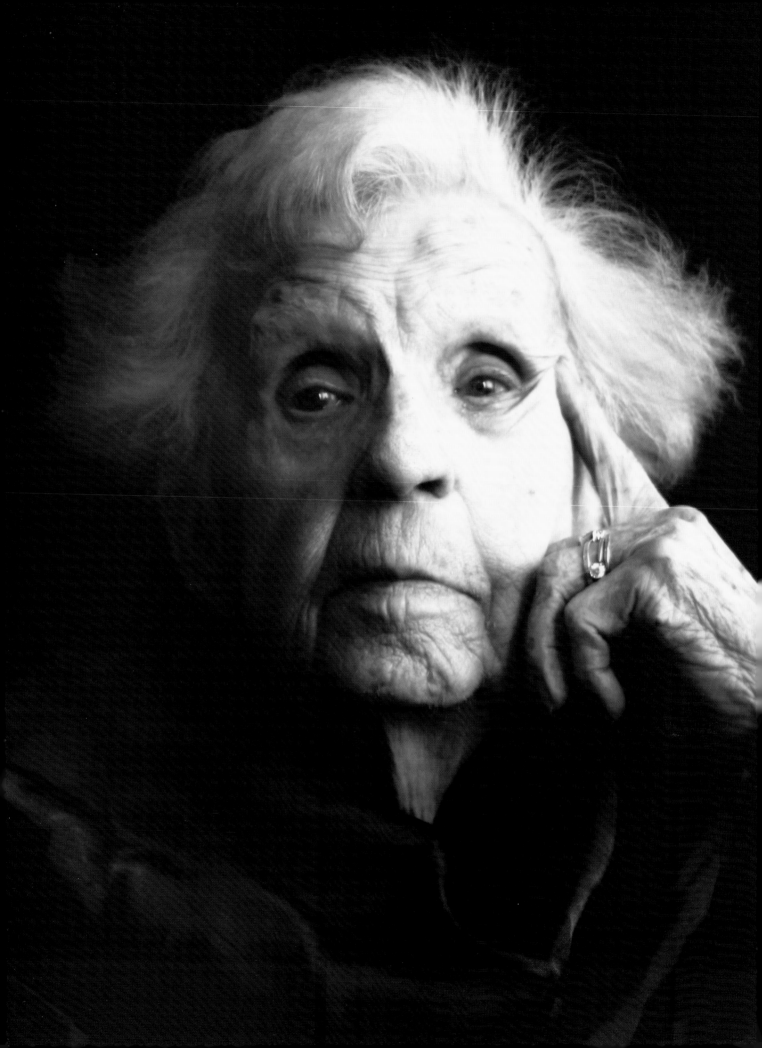

I can get in more trouble accidentally
than most people can get into on purpose.

Marie Meuser Baker Frye, age 99
Tulsa, Oklahoma

Born October 7, 1906, in Peru, Illinois.
Photographed May 23, 2006 in Tulsa.
Moved to assisted living after driver's license revoked.

Index